PALM SPRINGS STYLE

This work is dedicated to Robert Imber for his collaboration,
to Tony Merchell, Bill Butler, Stewart Williams, Donald Wexler,
Julius Shulman, and my sweet Pierre & Jane Coquelle.

© 2005 Assouline Publishing
601 West 26th Street, 18th floor
New York, NY 10001, USA
Tel.: 212 989-6810 Fax: 212 647-0005
www.assouline.com

Translated from the French by Sharon Grevet

Color separation: Gravor (Switzerland)
Printing by **Partenaires Book®** (JL)

ISBN: 2 84323 743 2

Aline Coquelle

PALM SPRINGS STYLE

ASSOULINE

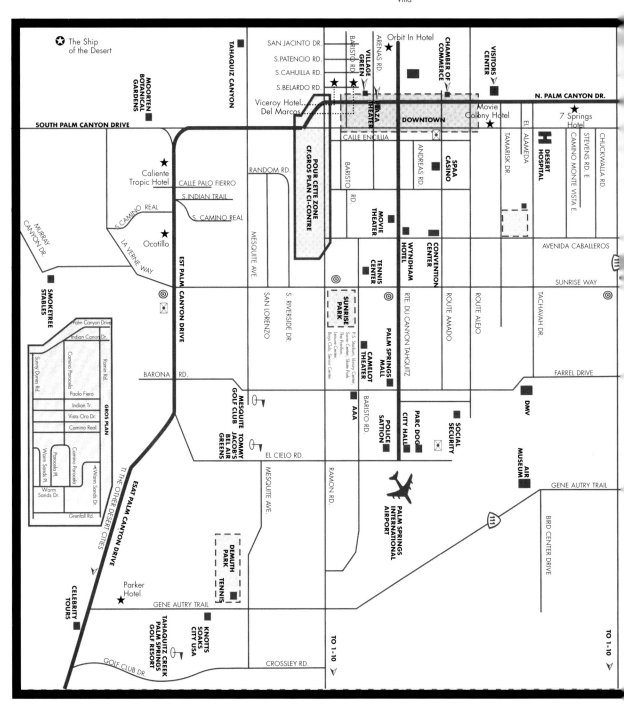

Frey II
Bougain Villa

The Ship of the Desert

TAHAQUIZ CANYON

MOORTEN BOTANICAL GARDENS

SAN JACINTO DR.
S.PATENCIO RD.
S.CAHUILLA RD.
S.BELARDO RD.

Orbit In Hotel
CHAMBER OF COMMERCE
VISITORS CENTER

BARISTO RD.
ARENAS RD.
VILLAGE GREEN
BARISTO RD.

Viceroy Hotel Del Marcos

PLAZA THEATER

DOWNTOWN

N. PALM CANYON DR.

Movie Colony Hotel

7 Springs Hotel

SOUTH PALM CANYON DRIVE

Caliente Tropic Hotel

CALLE PALO FIERRO
S.INDIAN TRAIL

S. CAMINO REAL

Ocotillo

MURRAY CANYON DR.

S. CAMINO REAL

LA VERNE WAY

POUR CETTE ZONE CF.GROS PLAN CI-CONTRE

CALLE ENCIILIA

BARISTO RD.

ANDREAS RD.

SPAA CASINO

EL ALAMEDA

TAMARISK DR.

DESERT HOSPITAL

STEVENS RD. E
CAMINO MONTE VISTA E.
CHUCKWALLA RD.

RANDOM RD.

MOVIE THEATER

WYNDHAM HOTEL

TENNIS CENTER

CONVENTION CENTER

AVENIDA CABALLEROS

SMOKETREE STABLES

MESQUITE AVE.

S. RIVERSIDE DR.

S. LORENZO

SUNRISE PARK
P.S. Stadium, library Center, Swim Center, The Pavilion, Leisure Center, Boys Club, Senior Center

PALM SPRINGS TAHQUITZ

RTE. DU CANYON TAHQUITZ

ROUTE AMADO

ROUTE ALEJO

TACHAVAH DR.

SUNRISE WAY

Palm Canyon Drive
Indian Canyon Dr.
Sunny Dunes Rd.
Camino Parocela
Ramin Rd.
Paolo Fiero
Indian Tr.
Vista Oro Dr.
Camino Real
Parocela Pl.
Camino Parocela
Warm Sands Pl.
Warm Sands Dr.
Grenfall Rd.

GROS PLAN

EST PALM CANYON DRIVE

BARONA RD.

MESQUITE GOLF CLUB

TOMMY JACOB'S BEL AIR GREENS

EL CIELO RD.

CAMELOT THEATER

PALM SPRINGS MALL

AAA

BARISTO RD.

PARC DOG'S
CITY HALL

POLICE SATION

SOCIAL SECURITY

FARREL DRIVE

DMV

AIR MUSEUM

GENE AUTRY TRAIL

ESAT PALM CANYON DRIVE

TI THE OTHER DESERT CITIES

MESQUITE AVE.

RAMON RD.

PALM SPRINGS INTERNATIONAL AIRPORT

111

BIRD CENTER DRIVE

CELEBRITY TOURS

Parker Hotel

GENE AUTRY TRAIL

DEMUTH PARK
TENNIS

TO 1-10

TO 1-10

TAHQUITZ CREEK PALM SPRINGS GOLF RESORT

KNOTTS SOAKS CITY USA

CROSSLEY RD.

GOLF CLUB DR.

Elrod House

Kenaston House

CONTENTS

The map on the left contains these labels:

Loewy House
Kaufman House (fman)
VISITORS CENTER
GAS STATION
TRAMWAY
ON DR.
TO 1-10 ›
RACQUET CLUB RD
VICTORIA PARK
O
S
N
E
PALM SPRINGS COUNTRY CLUB
★ HOTEL PRÉSENTÉ DANS CET OUVRAGE
◎ MAISON PRÉSENTÉE DANS CET OUVRAGE
PARC
GOLF
ATTRACTION
SUPERMARCHÉS
BUREAU DE POSTE
© www. palm-springs.org

ON THE ROAD	06
MODERNISM IN PALM SPRINGS	16
HOMES	29
Frey II	30
Elrod House	38
D'Angelo House	48
Loewy Residence	56
Kaufmann House	62
Grace Lewis Miller House	70
Kenaston House	78
The Ship of the Desert	88
Bougain Villa	94
HOTELS	103
Viceroy Palm Springs	104
Parker Palm Springs	110
Del Marcos Hotel	116
Caliente Tropics Resort	122
Ocotillo Lodge	126
CONDOMINIUMS	130
The Park Imperial South Condominium, Sandpiper Condominium, Seven Lakes...	
PALM SPRINGS ART MUSEUM	140
REVIVAL OF THE MODERN	151
ADDRESS BOOK	168
ARCHITECTS	174
TESTIMONIES	178
BIBLIOGRAPHY	191
ACKNOWLEDGMENTS	192

ON THE ROAD

Palm Springs is a mirage. An improbable city set in the middle of nowhere. The map indicates that from Los Angeles, you take Freeway 10 going east. It's barely a two-hour ride to Highway 111, a long ribbon of asphalt that runs in a straight line through the Coachella Valley.

For a photographer, the desert is, above all, a palette of colors. The color of the sky: hard blue. The color of the light: soft and sensual in the morning, then increasingly white as the hours go by, until the evening, when the sun slips away to the west, splashing the San Jacinto Mountains with crimson and violet.

But the Mojave Desert is also about texture and grain—a material kneaded by the heat and light, and burnt by the sun. It is a jumbled and violent relief, a pure elemental landscape.

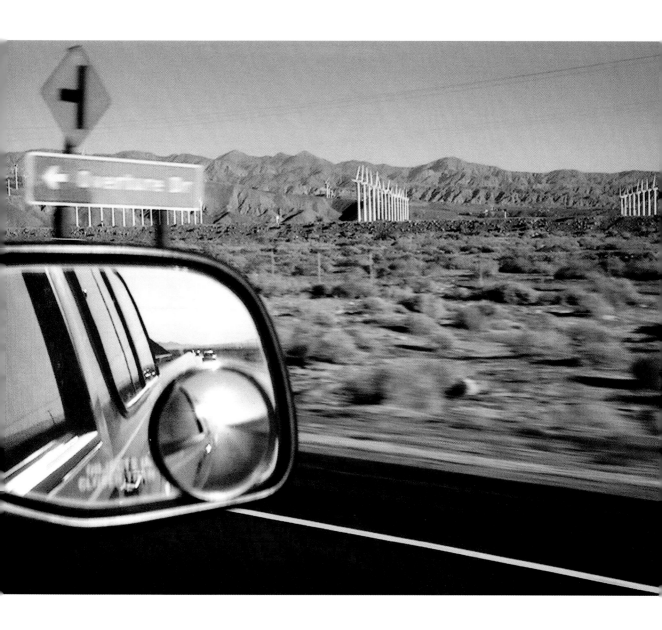

And because it is also the setting for several of the most beautiful jewels of modern architecture, this desert is a photographer's dream. It is an open-air studio where the likes of Julius Shulman, Slim Aarons, and Bruce Weber have worked. I could have easily imagined running into Ansel Adams, Garry Winogrand, Stephen Shore, or William Eggleston.

And then there is Palm Springs. Until the late 1960s, it was *the* glamour destination, the place to be if you were in the know—a fast, inventive, sometimes frenetic, but always soothing city frequented by West Coast high society. And then, in the 1970s, the beauty fell asleep.

In the mid-1990s, Palm Springs finally awoke from its torpor. Today it is alive again. And photographing it implies producing images that speak of seduction, harmony, and visionary modernity. Palm Springs is an aesthetic and visual city, designed by the finest conceptual architects. They imagined Palm Springs. And in my opinion, images alone can reveal their dream.

Therefore, this album is a tribute to that modern architecture built in the heart of an iconic oasis of contemporary culture.

In the 1930s, and then again in the 1950s and 1960s, Palm Springs was a favorite spot for Hollywood stars who were attracted by its winter sun, surrealistic landscapes, therapeutic desert silence, and also its relative proximity to the studios. An absolute paradise.

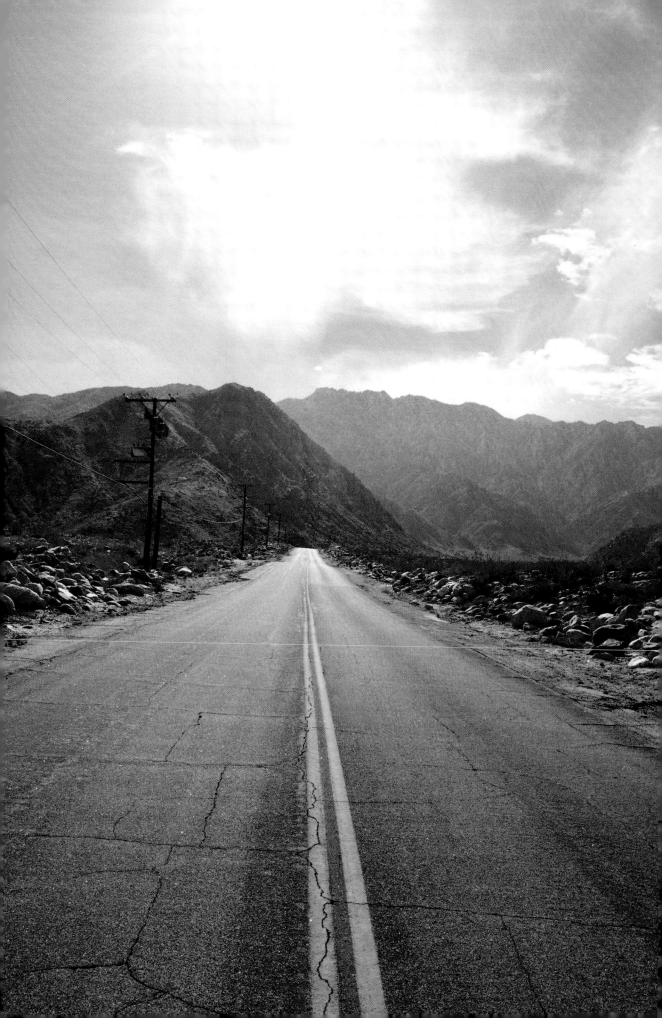

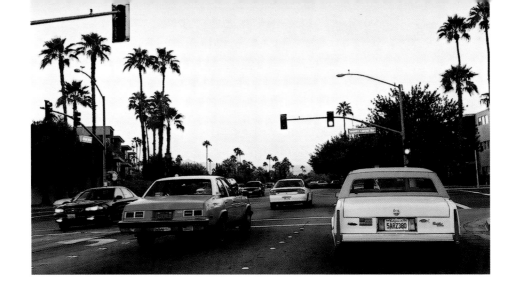

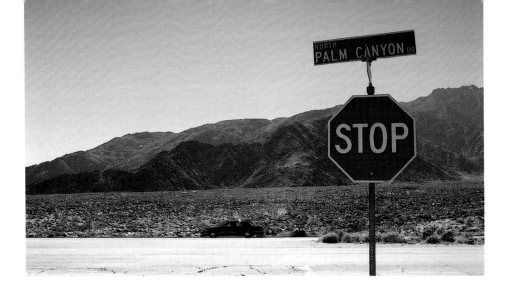

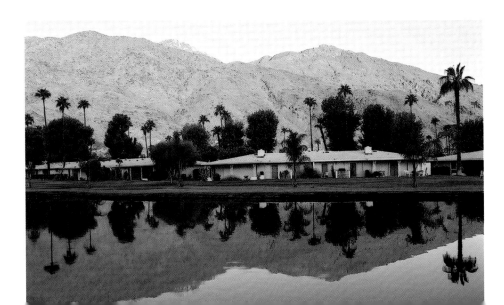

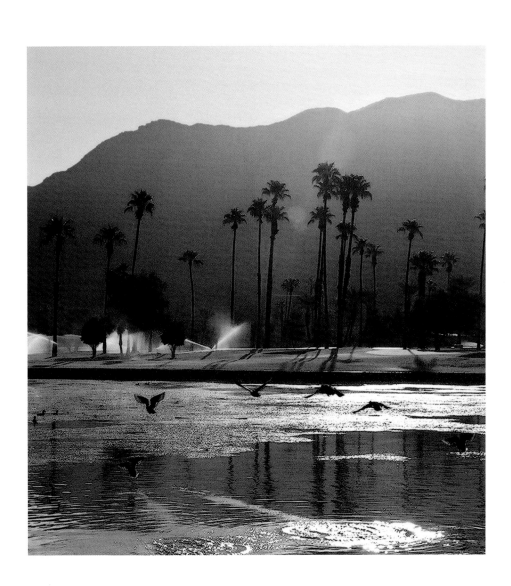

Marquee names like Marilyn Monroe and Frank Sinatra, and industrialists and producers like Raymond Loewy and Howard Hughes, stamped Palm Springs with an aura of glamour, luxury, parties, and sexy sun. Through a rebound effect fostered by the European creations of Ludwig Mies van der Rohe, Le Corbusier, and Walter Gropius, the cream of American architects designed refined homes in harmony with the panorama of the Low Desert for tycoons from Hollywood and elsewhere. Also seeking relaxation and sun, the emerging American middle class gradually followed suit.

Today Palm Springs, considered the greatest concentration of modern architecture in the world, has been rediscovered by international architects, designers, photographers, and the jet set, who have once again been lured by its singular appeal and ideal climate.

MODERNISM IN PALM SPRINGS

Palm Springs has always been linked to the notion of pleasure and well-being. Centuries ago, the Cahuilla Indians migrated to this region, rich in curative hot springs, and developed communities in its canyons. Needless to say, that was long before Gene Kelly, Clark Gable, Elvis Presley, and even Albert Einstein deemed this city a haven.

To house the city's new Hollywood cast, the architectural elite employed modern, functional, and aesthetic concepts. In the early 1920s, Lloyd Wright, the eldest son of architect Frank Lloyd Wright, designed the Art Deco Oasis Hotel. And in 1922, Rudolph M. Schindler designed Popenoe Cabin, the first so-called modern-looking building, in Indio in the Coachella Valley, far from the epicenter of Palm Springs, which has since been destroyed. But it was not until John Porter Clark and Albert Frey, as well as Richard Neutra, John Lautner, William F. Cody, Stewart Williams, Donald Wexler, A. Quincy Jones, and William Krisel, that modern architecture truly arrived in Palm Springs.

American modernism was based on the international style, but rejected its austere rationalism in response to the fanciful and optimistic postwar art of living in the United States. Landscapes intermingle with inner spaces though the use of materials and techniques such as native rock, immense walls of glass, refined

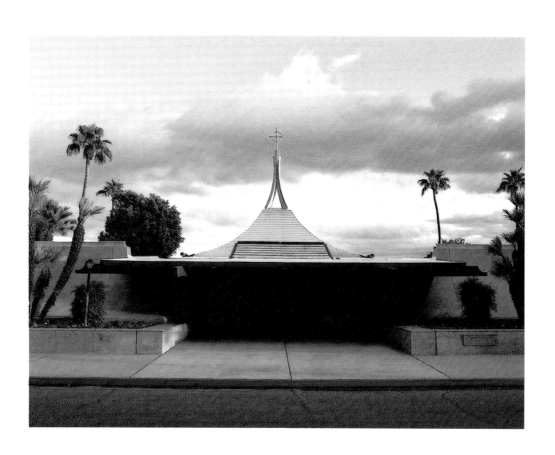

aluminum lines, ethereal butterfly-winged roofs, and swimming pools in the earth tones of the San Jacinto Mountains. Moving away from the California Hispanic style, with its opaque walls and structures dropped on the ground like blocks, modernism incorporates innovative designs that are viscerally connected to light with technology and a sense of supreme relaxation. The result is complete harmony with nature and landscape.

"They were the golden years of architecture," explains architect Donald Wexler, designer of the Palm Springs airport, the Dinah Shore House, the Alexander Steel Houses, numerous schools and buildings, as well as a gas station and a prison in Palm Springs. To Wexler, modernism is "an interplay of multiple experiments with emphasis on new technologies: metal framing, steel joinery, sliding glass walls extending to infinity, prefabricated modules, concrete slabs, etc., all of which mesh brilliantly with the natural rock."

Spatial organization was reviewed, and a new dialogue with the environment began, using Ludwig Mies van der Rohe's Barcelona Pavilion for the Barcelona International Exhibition of 1929—a transparent structure with atypical walls sliding outward—as a reference. Freedom of design became absolute; modernism conveyed a willingness to live out one's imagination and dreams to the fullest. And that new freedom transcends each creation while preserving a

minimalist ethic. The focus remained on the essentials, perhaps in recognition of the preceding years of recession and war. Palm Springs modernism is perhaps the best expression of the golden rules of Mies van der Rohe—"Less is more"—and Charles and Ray Eames—"Doing the most with the least."

Today the relentless beauty of the desert continues to pay tribute to this architectural movement. Modernism makes itself felt everywhere in Palm Springs. Residential, commercial, religious, and institutional architecture all exude the innovative precepts that make Palm Springs the incontrovertible mecca of the modern era, a veritable open-air museum. The top ten architects of the 1950s and 1960s tackled urban construction of every sort, including schools, banks, supermarkets, the airport, churches, motels, hospitals, and bus stations, raising Palm Springs to the status of an icon. In this legendary desert town, modernism may well prove itself to be the greatest star of all.

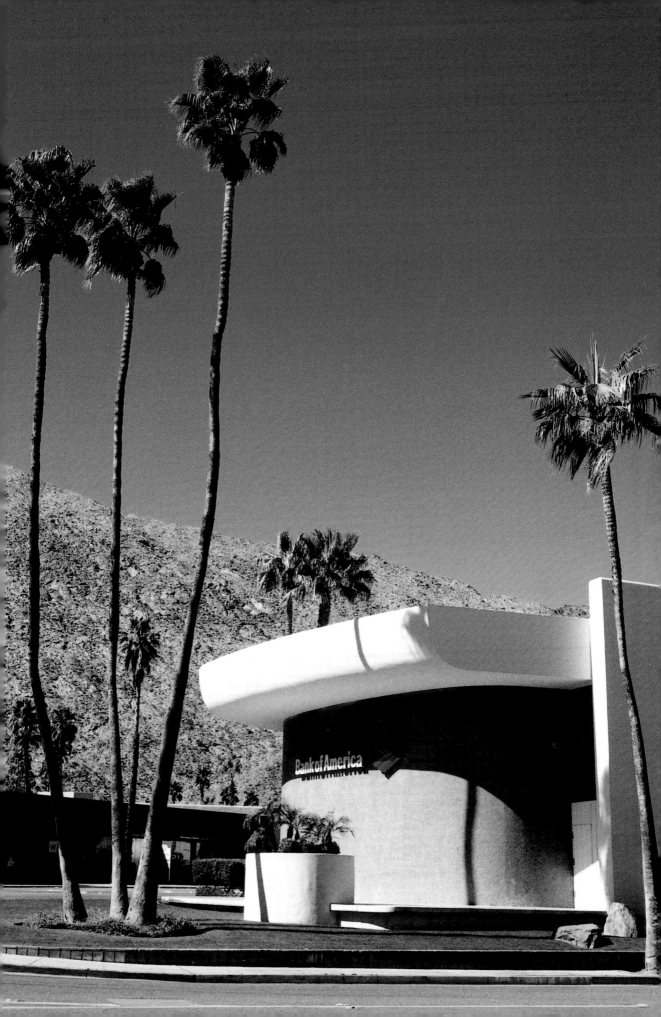

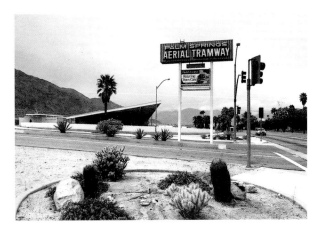

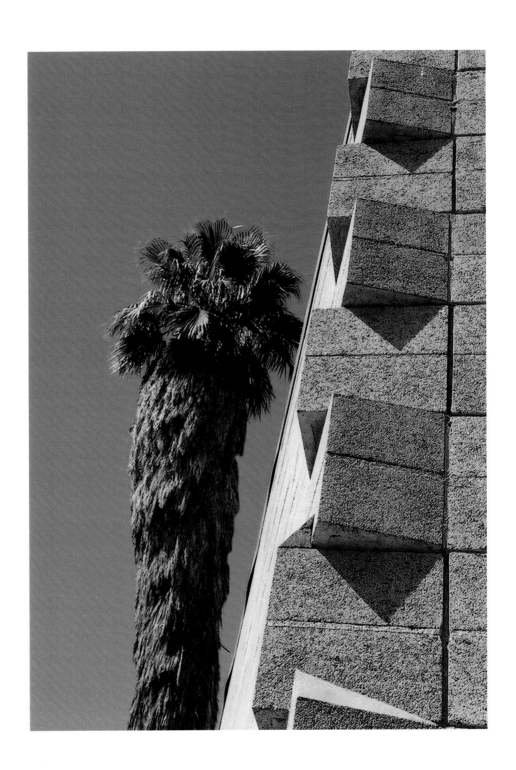

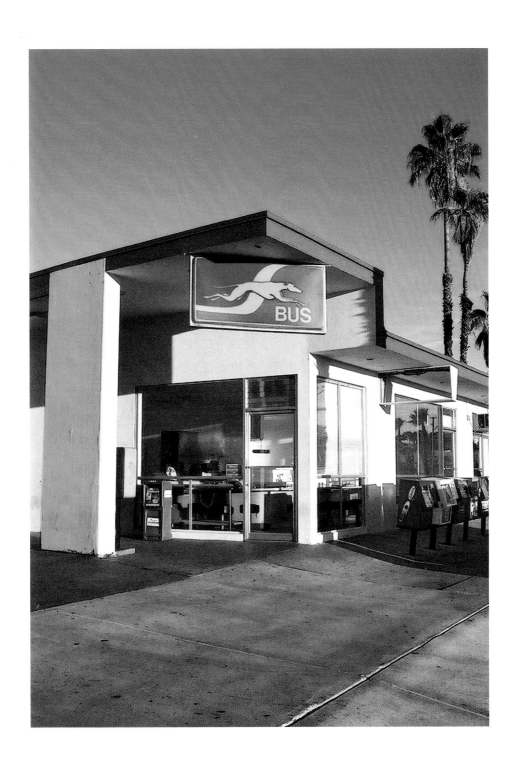

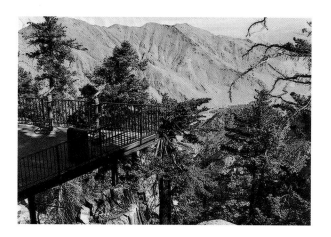

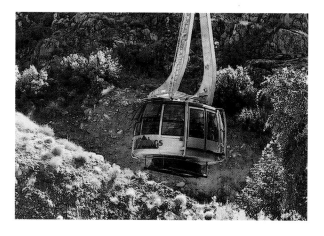

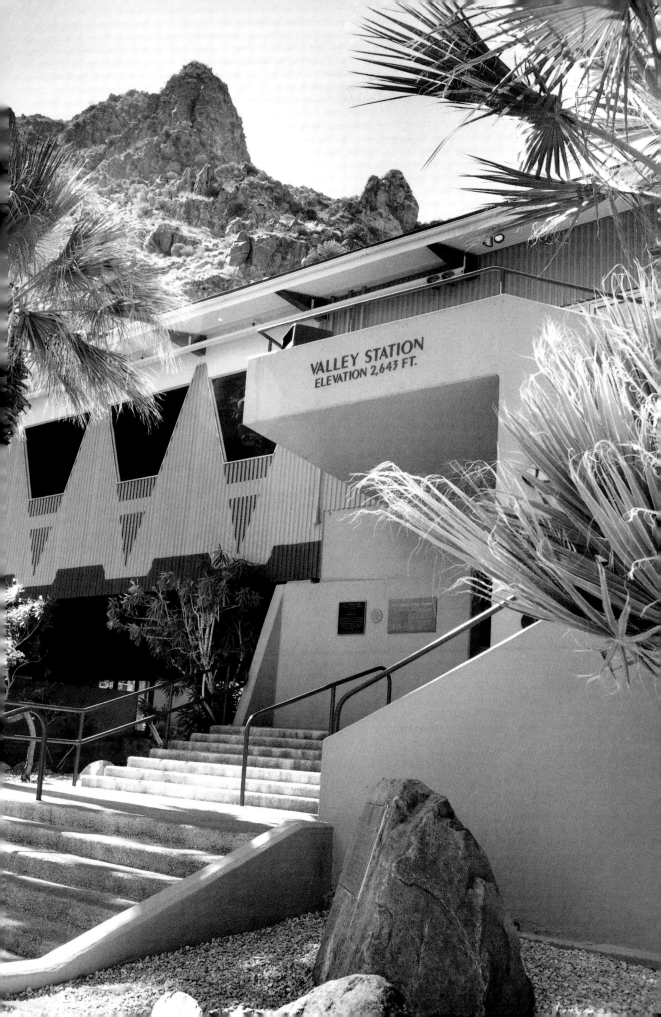

VALLEY STATION
ELEVATION 2,643 FT.

HOMES

Touring Palm Springs in search of its modern gems is a both chic and exotic adventure. Civic and religious buildings, hotels, gas stations, and stores are there for all to see. But the silhouettes of private residences are often hidden by curtains, greenery, or inaccessible private roads. One needs to be in on the secret to gain access to these ultimate objects of California desire. The various testimonies of the owners (p.178 and after) give us an essential, intimate and exclusive access to these houses. Our warmest thanks to each of them.

FREY II

Architect: Albert Frey

Bequeathed to the Palm Springs Art Museum, Frey II (1963), the last residence of legendary architect Albert Frey, is open only to architects, researchers, and art historians. Entrance to Frey II, the architect's laboratory of life and center of architectural experimentation, is considered an extreme privilege. Born in Switzerland, Frey was a student of Le Corbusier and a fan of the pioneering California spirit. One of the greatest names in Palm Springs architecture, Frey designed not only residences (including the Raymond Loewy House) but also many of the city's cult monuments, including the Tramway Gas Station, the Palm Springs Aerial Tramway Station, City Hall, and various churches, schools, and shops.

Frey II demonstrates its creator's architectural and philosophical precepts in an eruditely purist

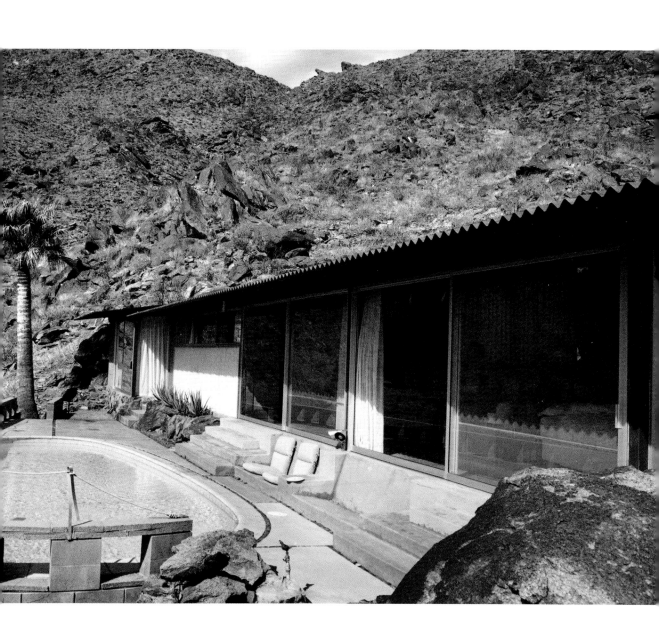

equation, despite its improbable topography; no other lot in Palm Springs is as rugged and highly perched. Boulders and cacti stud the ground, the slopes are imposing, and the sun seems to take pleasure in burning everything. Nevertheless, it was these rich textures, dramatic panoramas, and copper and tea green colors that inspired the architect. His house, "anchored to the rocks," as Frey liked to say, was integrated into the boulders of the Palm Springs landscape, and subsequently, its coral cement blocks took on the same patina as the desert. Also admirable is its human scale and custom design. Every square foot was planned without ostentation and exudes meticulous artistry. Some examples include a suspended surface that serves as both a drafting and dining table, built-in furniture made of cement and Philippine mahogany, and the sepia-corrugated aluminum roof, which viscerally harmonizes with every interior. The living room, dining room, and bedroom intertwine without partitions, communicating harmoniously with nature through constant interconnections. The pool solarium, designed as a roof sundeck over the garage, refreshes the ambient aridness, and animates and colors this unique creation.

Frey constantly endeavored to do more with less, and the "less is more" concept of Mies van der Rohe, Frey's spiritual mentor, has been applied here with verve. But one can also sense the influences

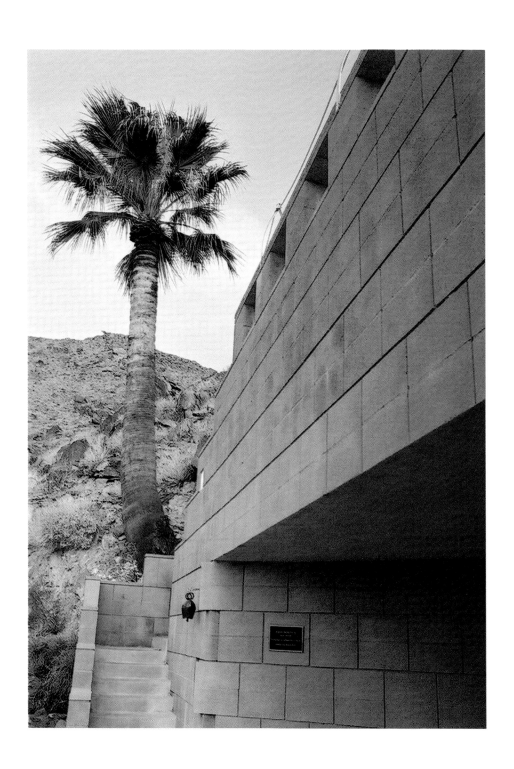

of Neutra, Schindler, and Le Corbusier. The architect considered it a duty to use humble and light materials, as well as the latest mass technologies, both to minimize the risks of earthquakes and as a commitment to economy. His official quest was to study the positions of the sun in order to make optimal use of its light, shadows, diffractions, and heat, and then integrate them into his constructions.

Frey once said, "We must learn discipline and functionality from nature, and draw on its creativity and wealth." And it was his profound collaboration with the elements that captivated Le Corbusier, and led him to comment to Frey: "I congratulate you on your creations, which are always pure and original." On extremely rough slopes, Frey ingeniously took up the structural and ethical challenge of integrating a modern habitat into a wild decor while simultaneously safeguarding and sublimating it. The result is high art. This residence seems a source of well-being, and accordingly, Albert Frey lived here until his death at age 95. In photographs taken by Julius Shulman, Frey appears on his sundeck, ascetic, serene, and in complete harmony with nature and his creation; a touching fusion, an avant-garde, ethical life lesson.

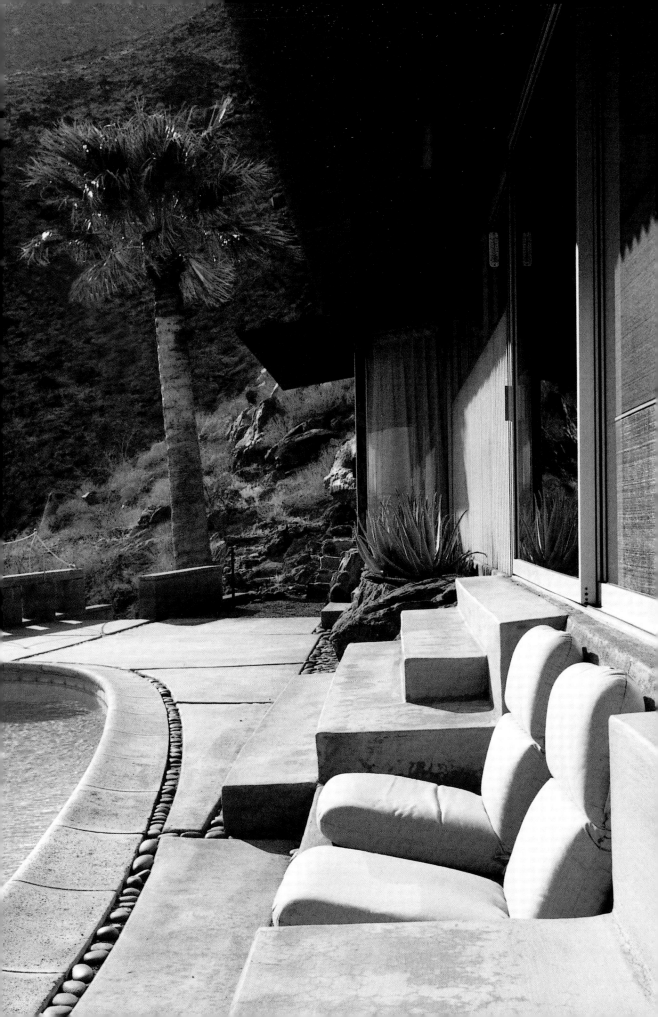

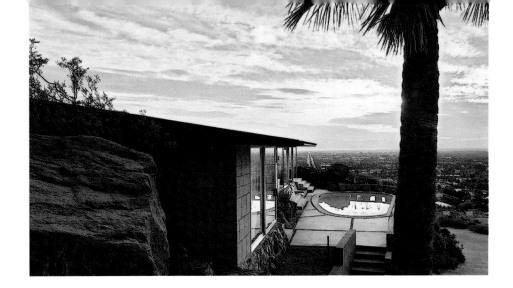

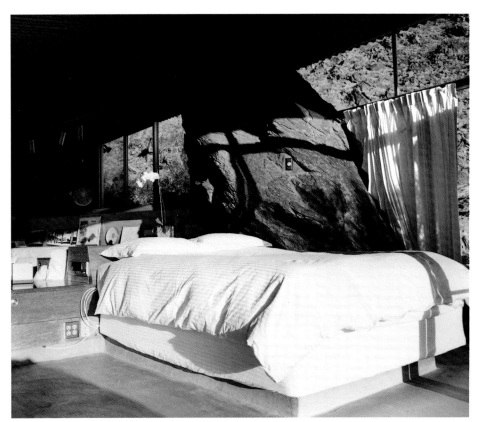

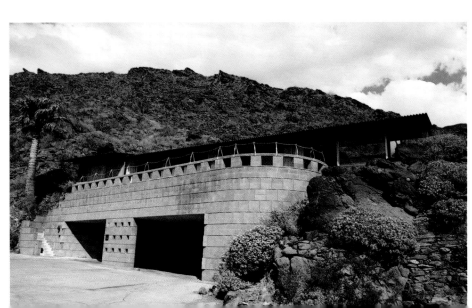

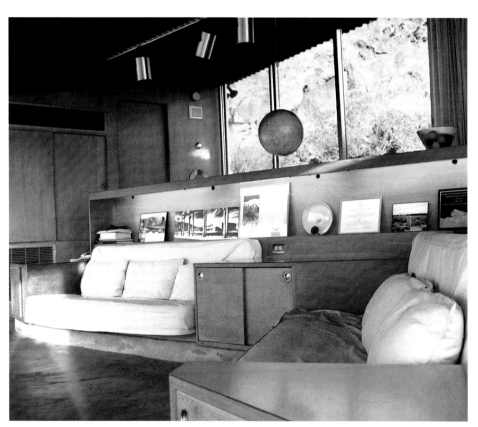

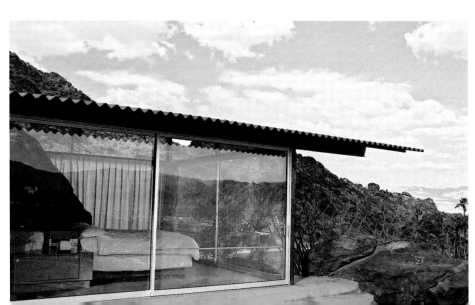

ELROD HOUSE

Architect: John Lautner

On the slopes opposite Frey II, the gigantic roof
of the Bob Hope residence and the curves of
Elrod House stand out in the distance, both
created by John Lautner.

Since its appearance in the 1971 James Bond film
Diamonds Are Forever, the Arthur Elrod House
(1968) has been an object of intrigue and envy.

After moving offices from Beverly Hills to Palm
Springs, interior designer Arthur Elrod wanted a
residence on par with the splendor of the land-
scape, modernist audacity, and a rarefied art of
living. He was looking for excellence, and at the
time John Lautner was the leading name in archi-
tecture. The residence's defining characteristic is
its roof—a cone-shaped concrete dome poured
over a primary structure. This form-stripped roof
is the karma, the radiation of the residence, with
its ingenious and discreet apertures, open to the

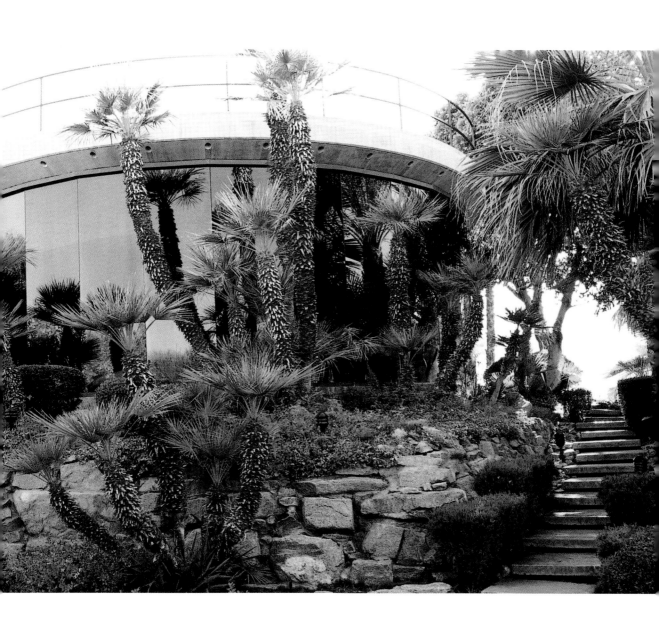

sky and protected by glass and sun shades. The roof's graphic style, representing a minimal desert flower of tremendous proportions, structures the work.

The house's current owner, Michael Kilroy, an epicurean tycoon and fan of modern architecture, opened his doors to us.

To reach Elrod House, one must drive up a private road on the precipitous slopes of Palm Springs, pass a guard post, climb a winding road bordered with elegant and distinguished palms, and park in a wing hidden from the improbable residence before passing through two glass doors that present this architectural icon. Upon entering, one experiences a feeling of sweet weightlessness, a serenity created by the curves of the house's entirely rounded architecture, tacitly open to the exterior. As in other examples of modern architecture, inside Elrod House blocks of boulders are invited into the living room, outline a bathroom, and frame a stairway. At the touch of a button, the vaulted central picture window totally disappears, giving an impression of infinite space. The surrounding landscape resonates within Elrod House: Its light, aromas, aura, and even texture invade its evanescent interior. Its raw concrete structure seems to echo the ruggedness of the desert while encroaching upon it with its monumental size.

The exploration of concrete, from walls to roof, became the architect's trademark, also exemplified by the sublime Arango House in Acapulco

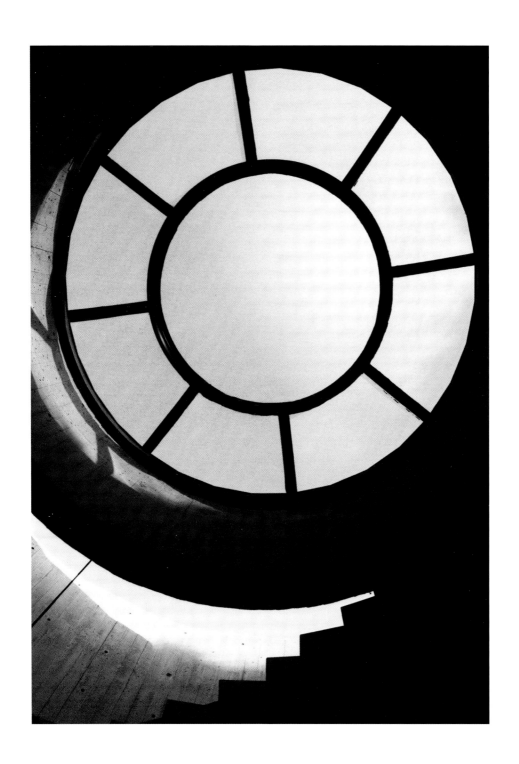

(1973), the Turner House in Aspen (1982), and his first fruit, the Garcia House on Mulholland Drive (1962). Here, the allure of its patina is in its tones, from pearl gray to blond, burnt by the desert sun and brought to life by the interplay of the shadows from the vegetation.

While working on the project, Elrod and Lautner earned a great respect for each other, and their encounter led to several joint ventures, including the legendary Bob Hope residence in Palm Springs—a collaboration tragically cut short by Elrod's accidental death in 1974. Elrod House was the fruit of their cooperation: Elrod designed and selected the furnishings, from the central rug created by Edward Fields to the Martin Brattrud sofas and other discoveries by Knoll, Harry Bertoia, Warren Platner, and Marcel Breuer. Teak partitions and walls, slate and textured-wood flooring, and original boulders illuminate the raw setting. Outdoors, bamboo curtains, cacti, eucalyptus, mandarin orange trees, California palms, and landscaped alleyways run through the curves of this stellar architecture.

With its oversize furnishings, and dramatic setting, Elrod House is the quintessential party pad—neighbors Steve McQueen and William Holden often attended parties thrown by Arthur Elrod. This art of living, so viscerally connected to nature, gave the word "opulence" a local connotation. But Palm Springs' opulence is not ostentatious; it is essential, rooted in nature, and, like a diamond, forever.

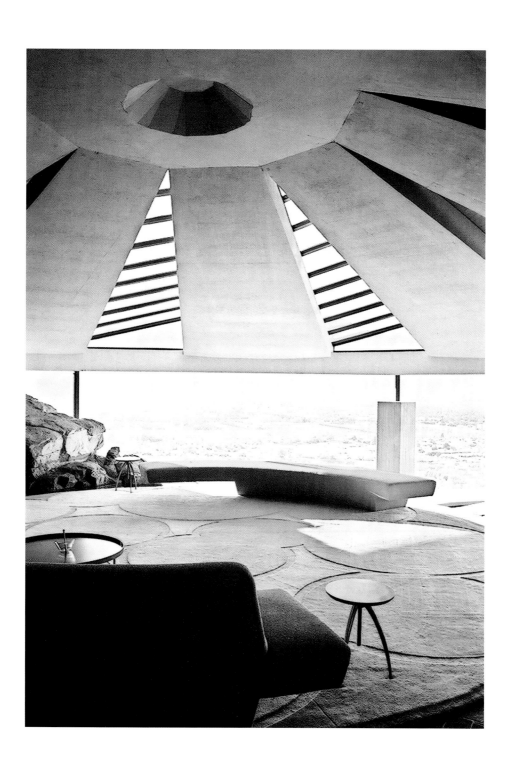

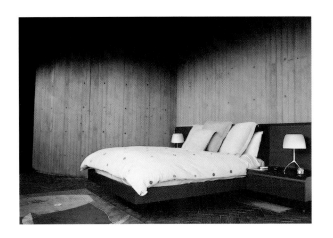

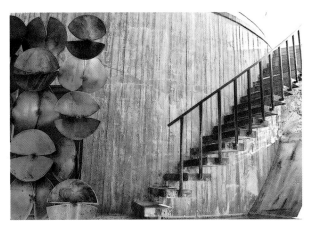

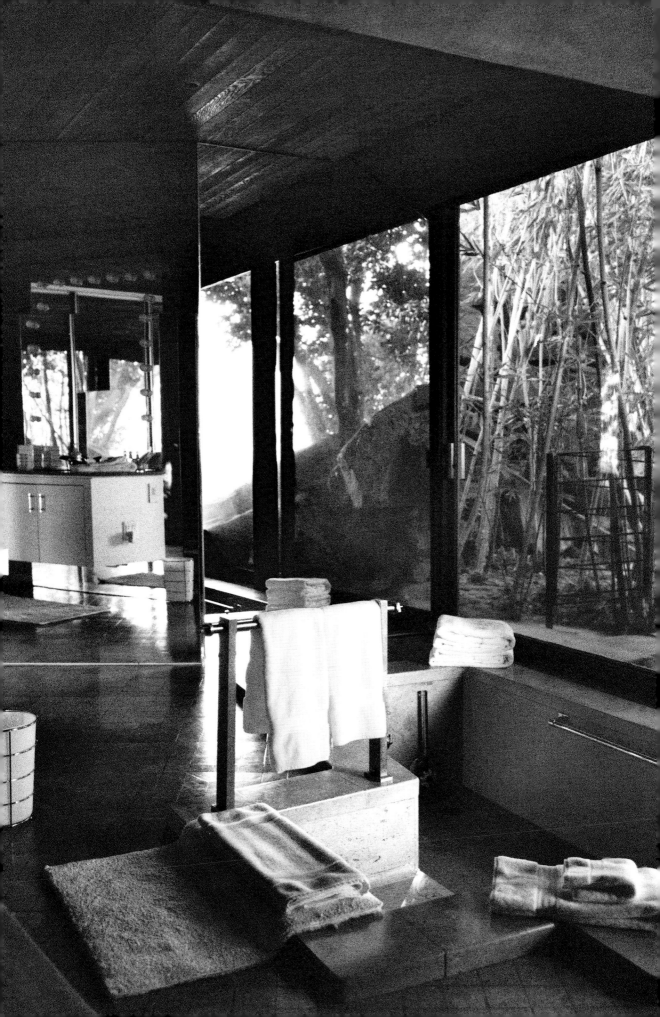

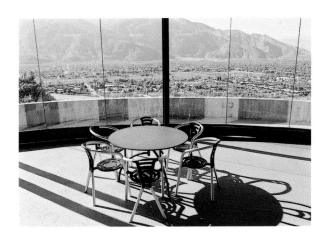

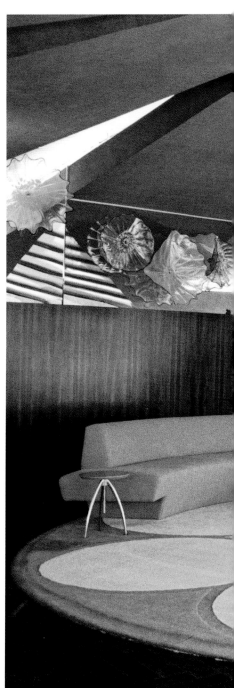

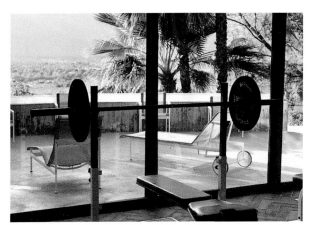

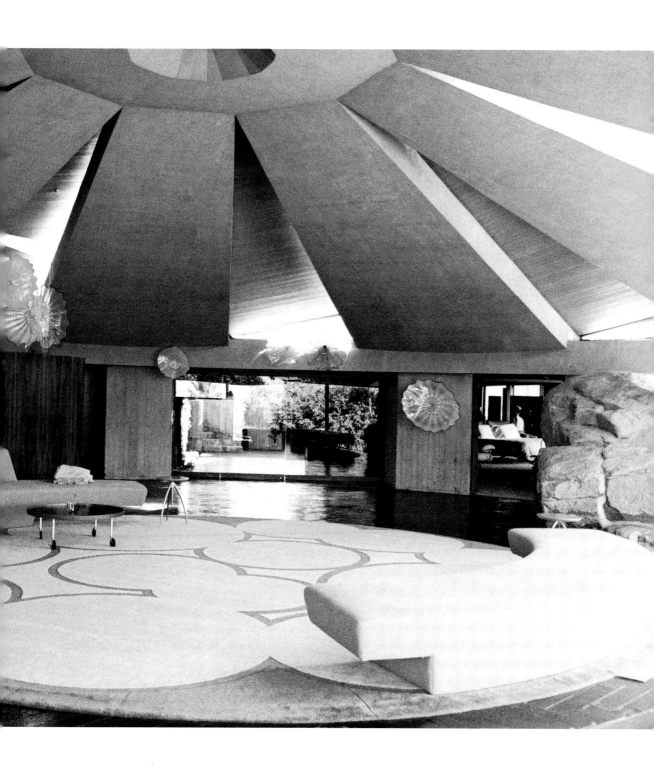

D'ANGELO HOUSE

Architects: Floyd D'Angelo and Harry Conrey

The D'Angelo House (1961) sits balanced like a UFO on the arid, rocky, quasi-lunar soil of Snow Creek. Custom designed by its owner, Floyd D'Angelo, a Los Angeles businessman and owner of Aluminum Skylight and Specialty Corporation, and engineer Harry Conrey, this one-piece aluminum prototype pivots on a motorized axis. One view follows another: the mountain peaks, the void of the desert, the giant Yucca Valley, the starry nights. D'Angelo once commented, "The house revolves at such a slow rate of speed that there is no sensation of movement. Concerning the entrance, it is provided by means of a circular porch, which extends around enough of the house circumference to accommodate the doorway at any position in the rotational arc."

It took a year and a half to restore and resuscitate this abandoned treasure after acquisition by the

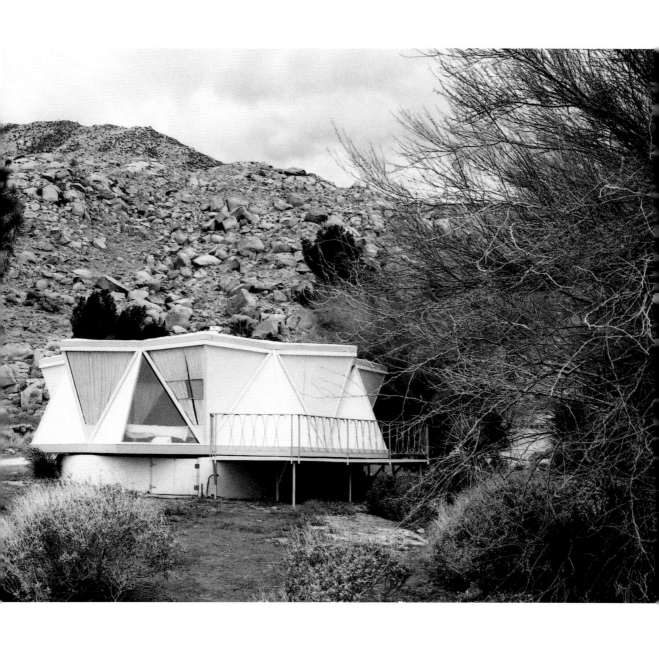

current owner Bill Butler. The exclusive photos in this book showcase its restored futuristic carousel, living room, bedroom, kitchen, and bathroom, all arranged around a central fireplace and a mind-boggling panoramic view. "The vast horizons, these seemingly painted mountains, the light...all that is an extraordinary decor, at least in my eyes, a creation tantamount to art," says Butler. "This is a magically happy place; the D'Angelo House makes you smile, thanks to its playful forms and unique location. It was a self-evident responsibility and, especially, a labor of love, to acquire, perpetuate, safeguard it."

More that just a residence, the D'Angelo house has been a haven for talent seeking respite and creative inspiration. Legend has it that the Beatles took refuge here during a series of West Coast concerts, and Butler is known for inviting artists to stay in his oasis. In 2004, this historic structure received a **PSMODCOM** Architectural Preservation Award, in the residential category.[1]

1. Bill Butler testimony's (p.180) offers a more technical interpretative framework of his residence.

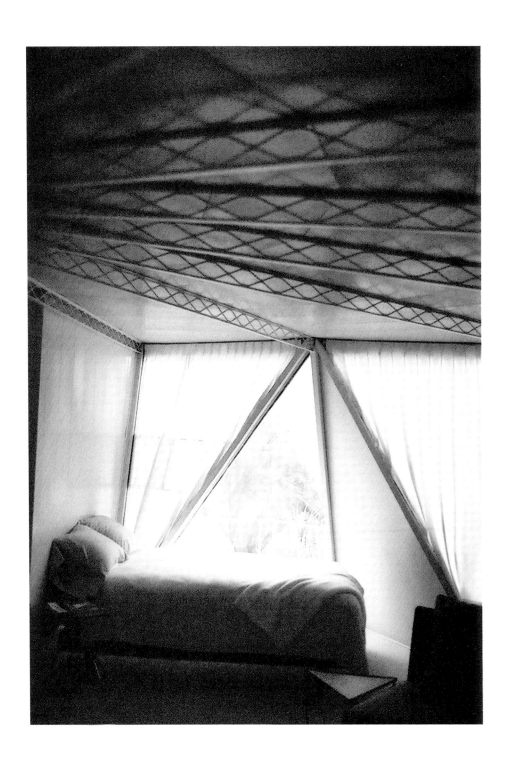

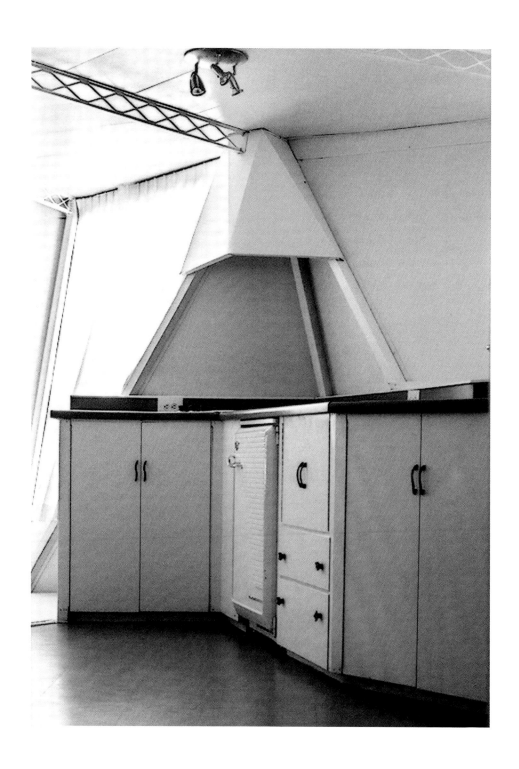

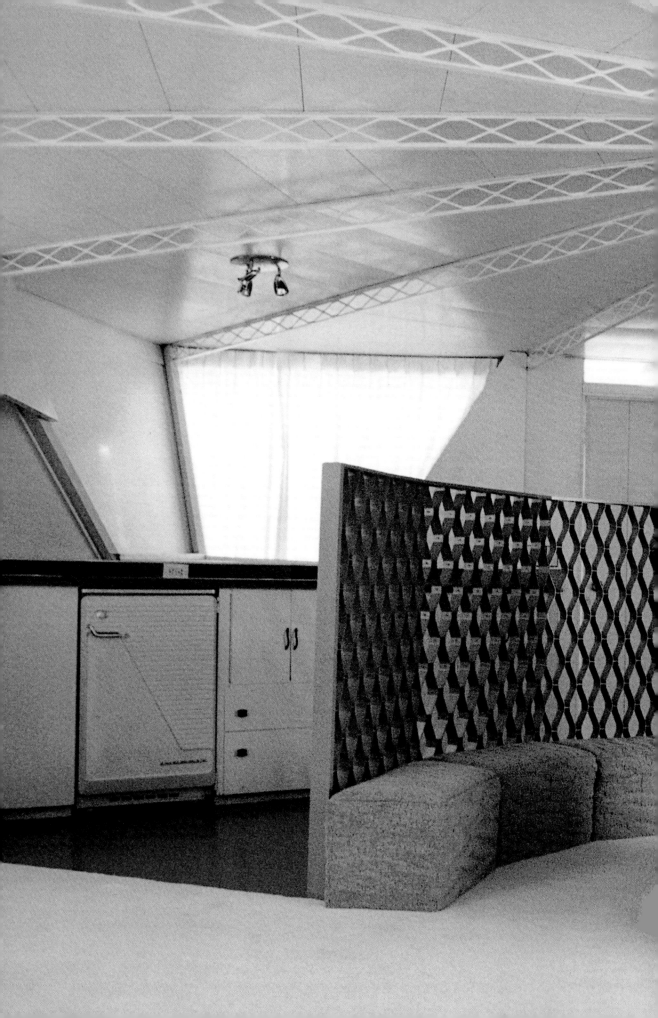

LOEWY RESIDENCE

Architect: Albert Frey

A short distance away in Las Palmas Heights, a sublime residential neighborhood at the foot of the San Jacinto Mountains, are two neighboring iconic homes, the Kaufmann House and the Raymond Loewy House. Each is a vintage 1946 masterpiece. Legendary industrial designer Raymond Loewy turned to architect Albert Frey to build his weekend house in Palm Springs. Loewy had already fallen in love with the light and surrealistic landscapes of the region, which he saw as haven just a short distance from hectic Los Angeles. "The colors of the desert are magical, the air is pure and invigorating, the nights are a dream. The smells, the sounds, the colors, harmonize in total beauty," he wrote in his biography, *Never Leave Well Enough Alone*, in 1953. He wanted a stylized design in tune with this paradise and applied his famous motto—"Refine, edit, simplify"—to his new residence.

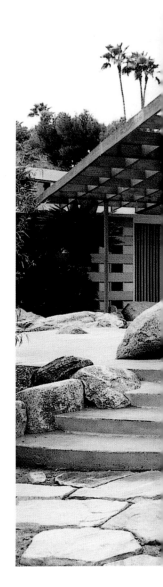

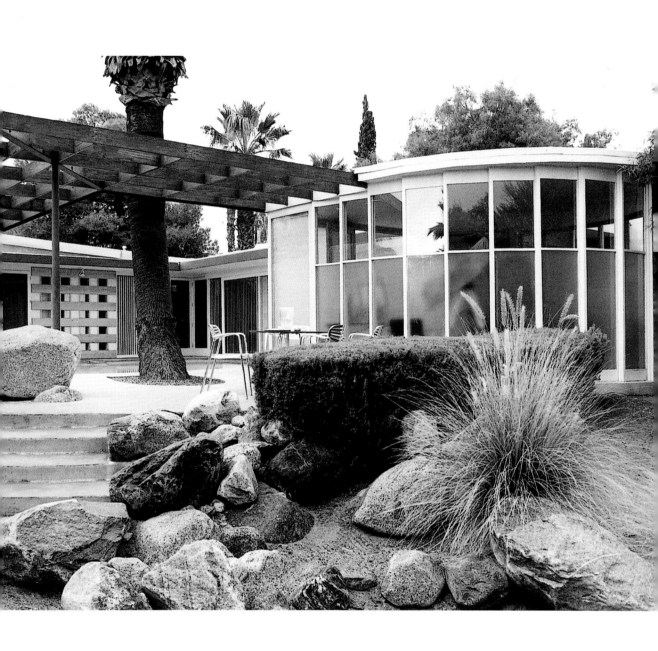

A swimming pool floats between the living room, deck, and primary rocks. The living modules are distributed along picture windows in continuity with the topographical curves. Loewy worked in close collaboration with Albert Frey and suggested the design of the silhouette of the living room roof and the use of cypress wood. He also suggested a small freestanding studio, perhaps to work on anthologies or to write his autobiography. Today, the Loewy House has become a veritable icon, a visual reference standard that has claimed its place as a twenty-first century design legend, and current owner Jim Gaudineer takes great pleasure in living there. He considers Loewy House to be an element essential to the equilibrium of his life, and admits he is under the spell of the beauty and serenity it exudes. Though he is aware that it is a historic landmark, Gaudineer does not want to transform Loewy House into the mausoleum of a bygone era. He does not understand the frenzy to single out the house at the expense of its intimate relationship with its contemporary resident. And while he respects the original design of this historic site, he also enjoys decorating its interior to his own tastes, far removed from the dictates of modernism, and without any curatorial or museological inflections. And there is a fundamentally good vibe—a sweet mixture of Frey, Loewy, and Mr. Gaudineer and his tribe.

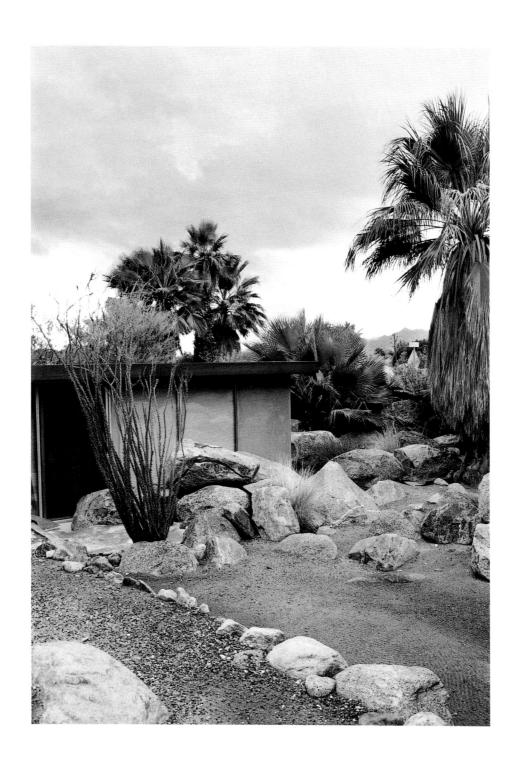

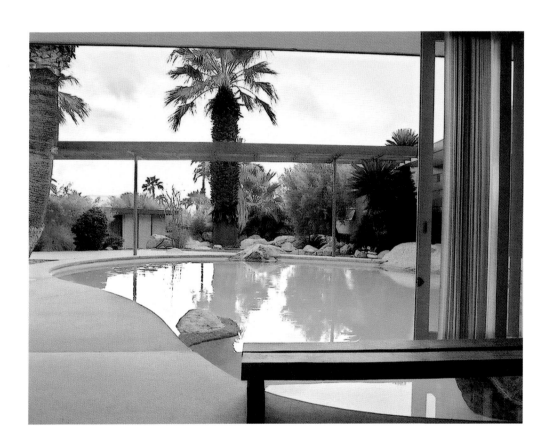

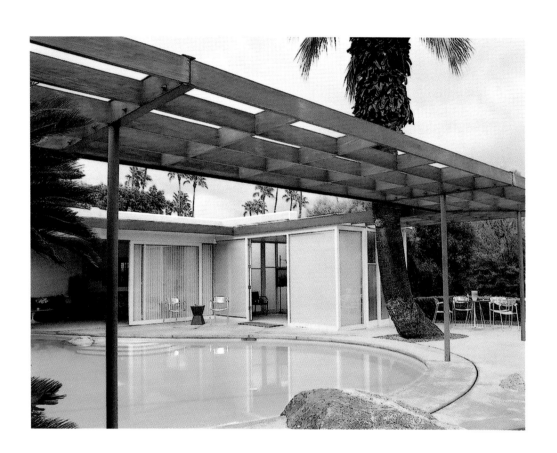

KAUFMANN HOUSE

Architect: Richard Neutra

A well-designed house affects all of our senses
of space (and) sense of smell, of touch, of
hearing, of temperature, and also of vision
(and) an obscure sense of materials.
—Richard Neutra

Through the gardens, a secret passage connects the
Loewy House with the famous Edgar J. Kaufmann
House designed by Richard Neutra. To walk the
path between them and experience first-hand the
sight of one of Neutra's greatest creations is a rare
visual shock. Finding oneself face-to-face with the
exact reproduction, but in full color, of the iconic
black-and-white Julius Sherman photograph, taken
in 1947 of a structure that would become one of the
defining works of modernism—it's an unforgetta-
ble moment. The image and the model seem time-
less and unchanged, but the magic of this place has
a secret: the talent and passion of current owners
Elizabeth and Brent Harris.

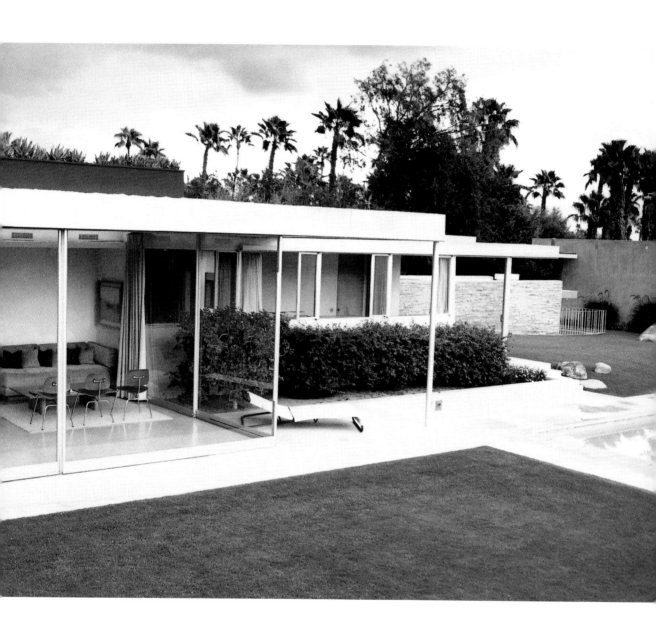

Thanks to their patient restoration, the Harrises have succeeded in sublimating and even transcending the original aura of this historic site commissioned by Edgar Kaufmann. Kaufmann was a Pittsburgh department store magnate and a zealous collector of houses, including perhaps the country's most renowned private residence, Pennsylvania-based Fallingwater, built by Frank Lloyd Wright in 1935.

In Palm Springs, Kaufmann wanted a villa where he could relax with his family—solely during the month of January—and take advantage of the winter sun. To execute his commission, Neutra built a Cubist structure carefully placed on a manicured lawn planted with cacti, lemon trees, and age-old boulders. A blue lagoon–like swimming pool, rangy Henrik Van Keppel lounge chairs, and Eames furnishings accessorized this Japanese-inspired creation with great chic. Walls of glass, stone, aluminum, and precious woods were fitted with a Zen refinement that has become a reference standard. Elizabeth and Brent Harris entrusted us with the keys to their villa—a singular privilege.

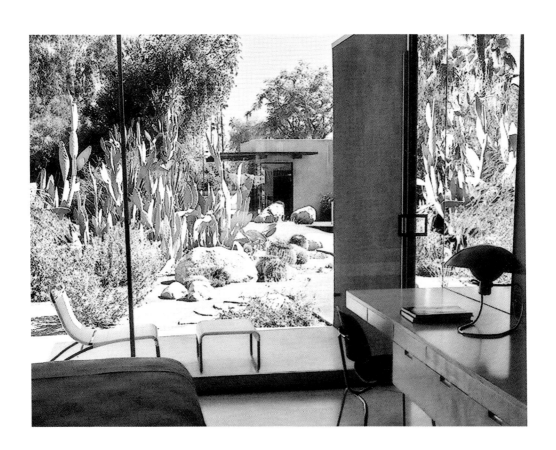

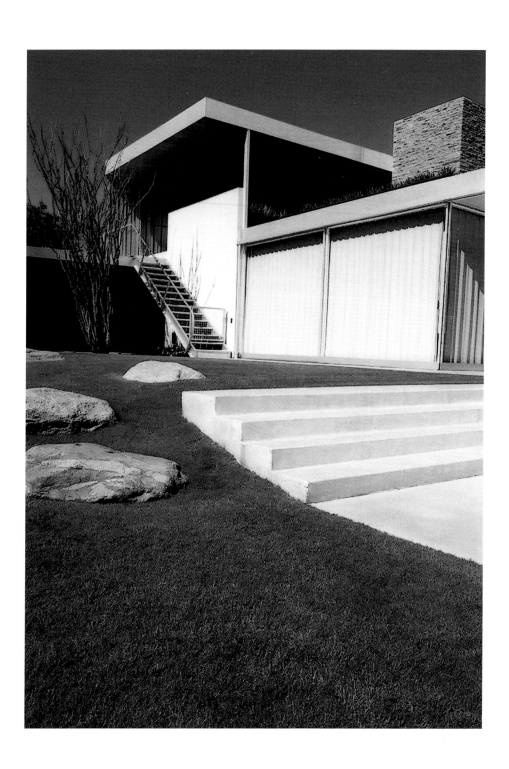

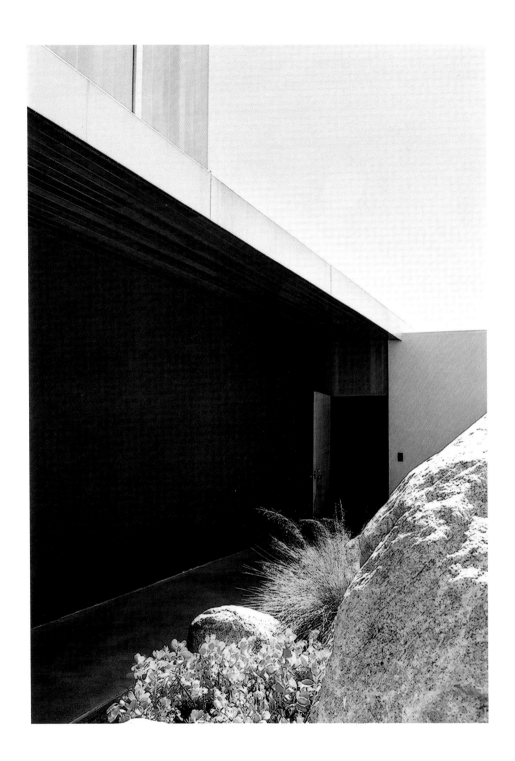

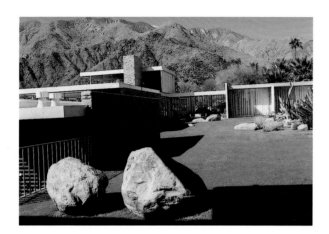

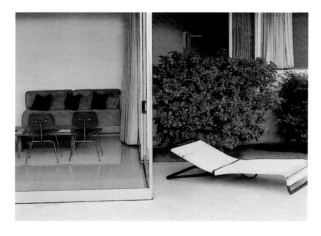

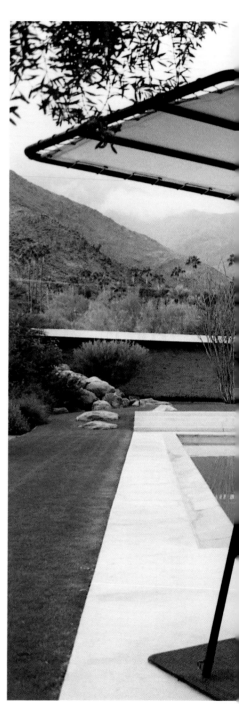

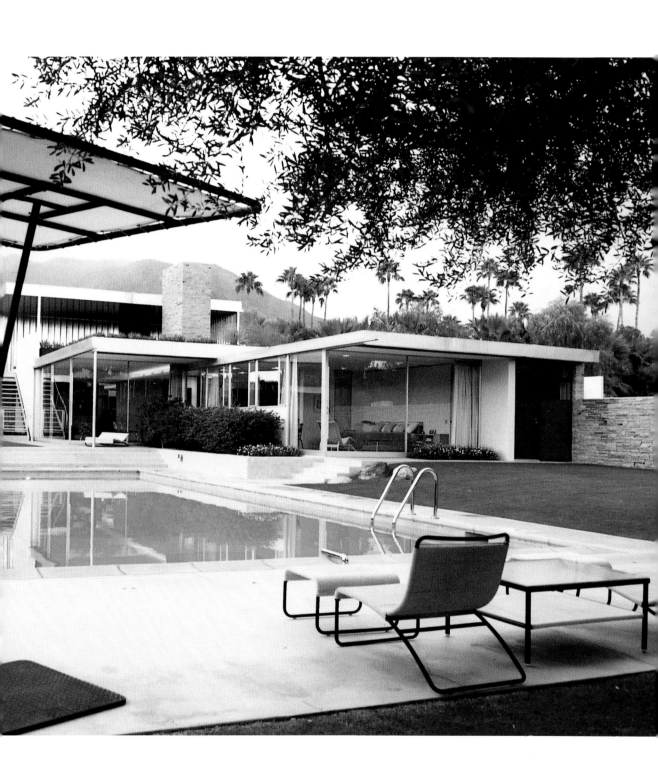

GRACE LEWIS MILLER HOUSE

Architect: Richard Neutra

Richard Neutra's first villa in Palm Springs, the Grace Lewis Miller House (1937), showcases his inventive and dexterous approach to construction in the mystic desert.

Grace Miller, the widow of a famous St. Louis surgeon, wanted a home in Palm Springs where she could both retire and teach her rhythmic body-training classes in the German Mensendieck Method of Functional Exercise. The therapeutic benefits, light, and wide-open spaces of Palm Springs made it the ideal choice. To execute her vision, Miller called upon her compatriot, Austrian-born Richard Neutra, to create a studio home in harmony with her new life. It was the architect's first trip to Palm Springs, and during it he was inspired by the California desert as well as reminiscences of his travels to Japan. With the building of the Grace Lewis

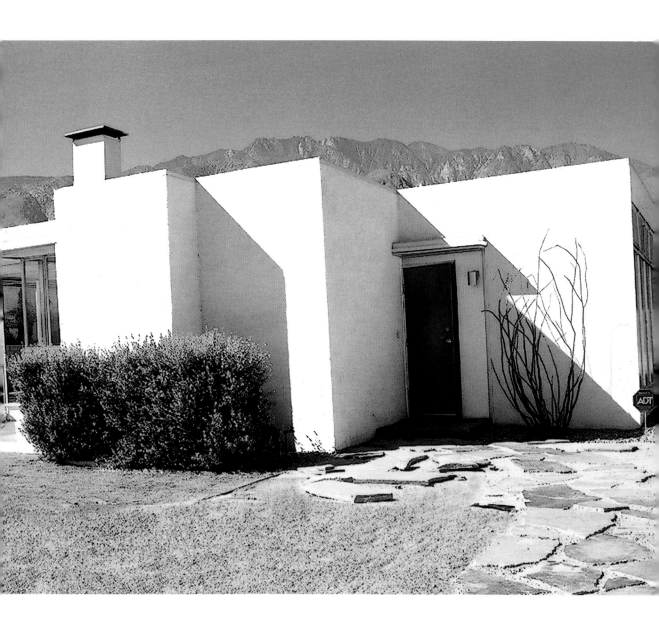

Miller House, Neutra inaugurated his spare, clean style, exalted by light and a form of pure architecture that echoes Japanese-style minimalism, where living spaces are multifunctional and stratified with fluid spatial transitions.

Here, mirrored panels expand the interior space and allow practitioners of the Mensendieck Method to observe their body movements while picture windows provide optimal natural, regenerating light. The close collaboration between Richard Neutra and Grace Miller turned into an ideal meeting of the minds.

The Miller House is a unique customized gem. Its proportions, designed for a single resident, are an extremely rare example of modern architecture. Saved from abandonment and an indescribable state of waste by Catherine Meyler in 2000, the Miller

House is gradually regaining its radiance. The restorations undertaken in accordance with the original building plans and Julius Shulman's vintage photographs are still in progress. "I bought the Miller House in 2000 on a whim, certain that a truly amazing home lay beneath the sad state that now apparent. The house was derelict and in severe disrepair. It had been added on to many times and was stripped of most of the original features. Over the past five years, I have attempted to restore the house to its original glory, and continue to do so," explains Catherine Meyler, the current owner. The photographs in this book show the initial stages of its rebirth; the garden has yet to be redesigned, the pool to be waterproofed, and the structure to be cleaned. But the soothing and intimate aura of this home endures. Catherine Meyler praises the beauty of her villa and sees each detail both through her passionate eyes, mixed with the lyrical vision of Grace Lewis Miller, who, for example, suggested in 1938 that the pool be integrated into the architectural framework: "The water tempers the effects of the sun," Miller wrote, "and provides marvelous reflections that dance on the ceiling of the living room and the veranda."

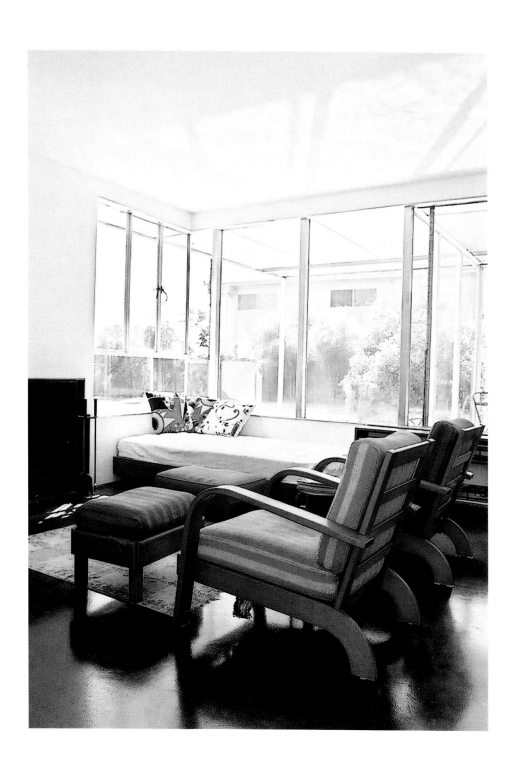

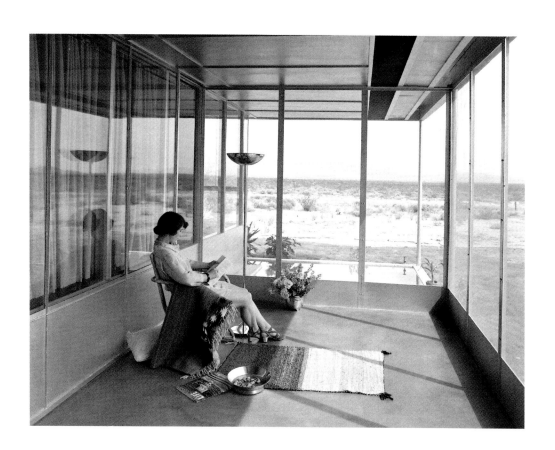

KENASTON HOUSE

Architect: Stewart Williams

At the edge of Palm Springs sits the Kenaston House, a work of art designed in 1957 by Steward Williams for Mr. and Mrs. Roberick Kenaston. Roberick Kenaston was the son of Robert Kenaston, the heir to a Minnesota fortune, and Billie Dove Kenaston, a silent film star who was recognized in Hollywood as one of the most beautiful women in the world and also one of the great loves of director Howard Hughes.

Today the Kenaston House is owned by Andrew Mandolene, a creative director, and Todd Goddard, a postmodern real estate specialist. In 2003, the pair came to Palm Springs to search for a vintage lamp in the specialized desert boutiques, but they returned to L.A. with a much more consequential purchase—the house of their dreams. It was true love at first sight, "a unique opportunity to acquire such a rare gem," they emphatically recollect.

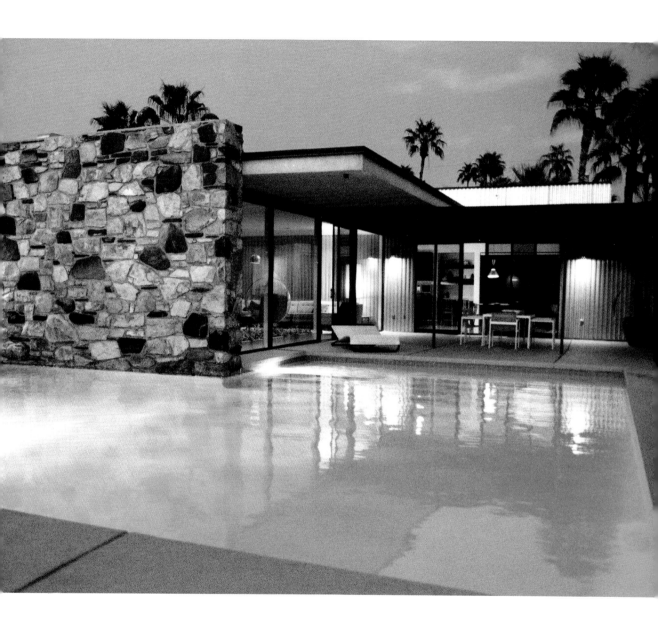

The 4,960-square-foot home's interior is composed of corrugated aluminum, natural rock, natural wood, and Masonite. There are four rooms, three baths, and a huge chef's kitchen with Gaggenau appliances. Exterior building materials include corrugated aluminum, natural rock, and stucco. The swimming pool, which butts against and wraps around a potion of the house, is exceptional. A half acre of land with more than thirty mature palm trees composes the garden; there is a large, walled side lot for a guest house, tennis court, or landscaped oasis, and a four-car garage with custom storage. The floating fireplace, glass walls, and indoor planting area are all Stewart Williams trademarks. Aware of its historical value, Mandolene and Goddard are restoring their new acquisition tastefully, minding original details and preserving its sophisticated

minimalist look in accordance with both Williams's refined plans and the specific codes of modernism. They treat their home like a treasure, choosing to adorn it only with vintage furnishings by such designers as Achille Castiglione, Richard Schultz, Henrik Van Keppel, Charles and Ray Eames, and Eero Saarinen. While their standards may seem strict, there is a lovely feeling of calm and, paradoxically, a great freedom in the midst of the elegant decor. With a decor ideal for photo shoots and exclusive parties, the couple has registered their villa with the Palm Springs Preservation Foundation as a world heritage site. Like many other owners, Todd and Andrew interpret Palm Springs as an art form, an artistic performance that is anything but a fad. And despite the signed Cachard paintings (originally owned by Frank Sinatra and Jack Warner) and the Paolo Roversi and Rob Mandolene photographs, the owners confess that they gaze just as often at the bare, solid aluminum walls and the interplay of positive and negative indoor/outdoor spaces of their Stewart Williams home. And what they love above all, when the evening sky turns lilac and crimson, and they sit comfortably ensconced in their Henrik Van Keppel chairs, is to inhale the pure Palm Springs air—as light and intoxicating as champagne bubbles.

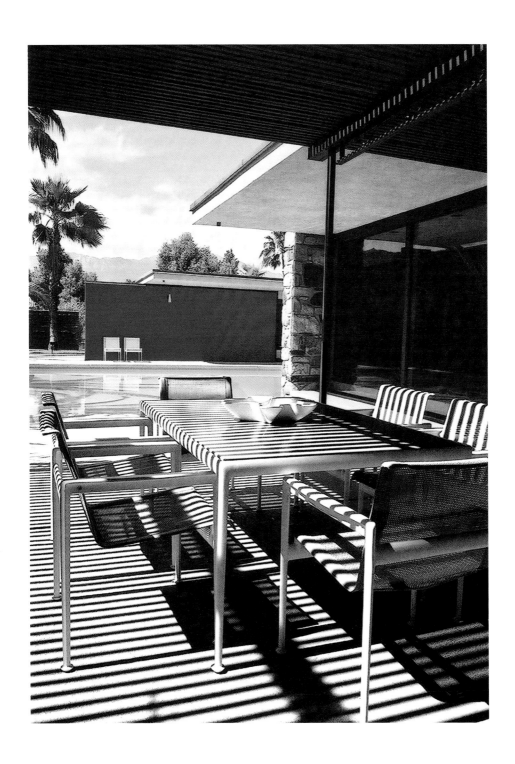

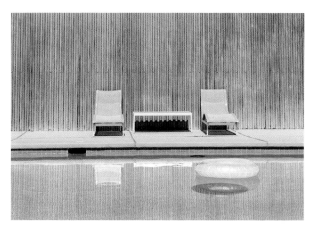

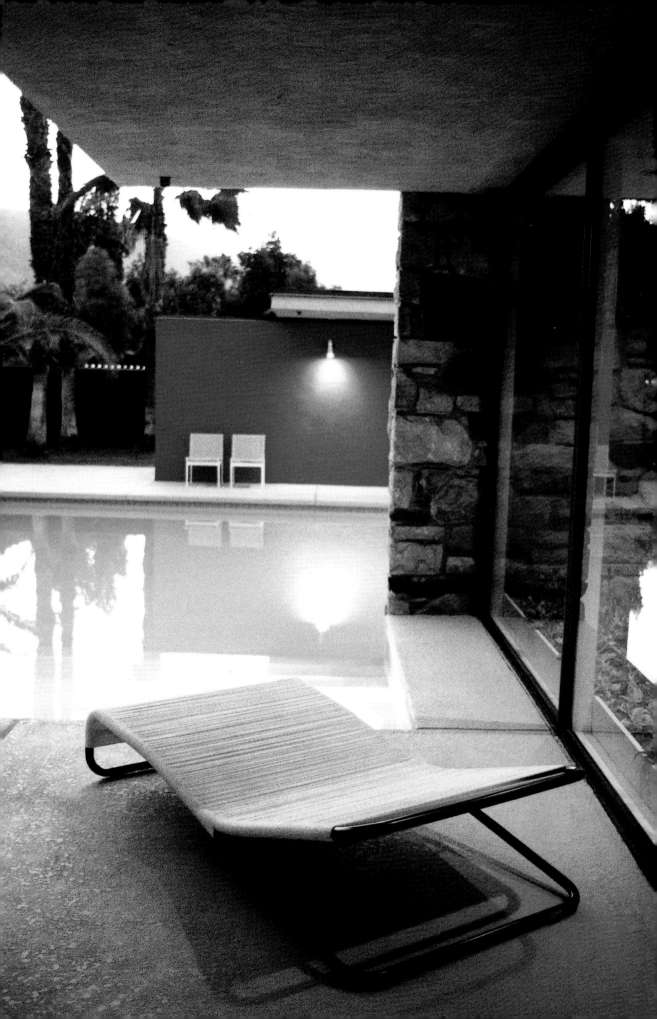

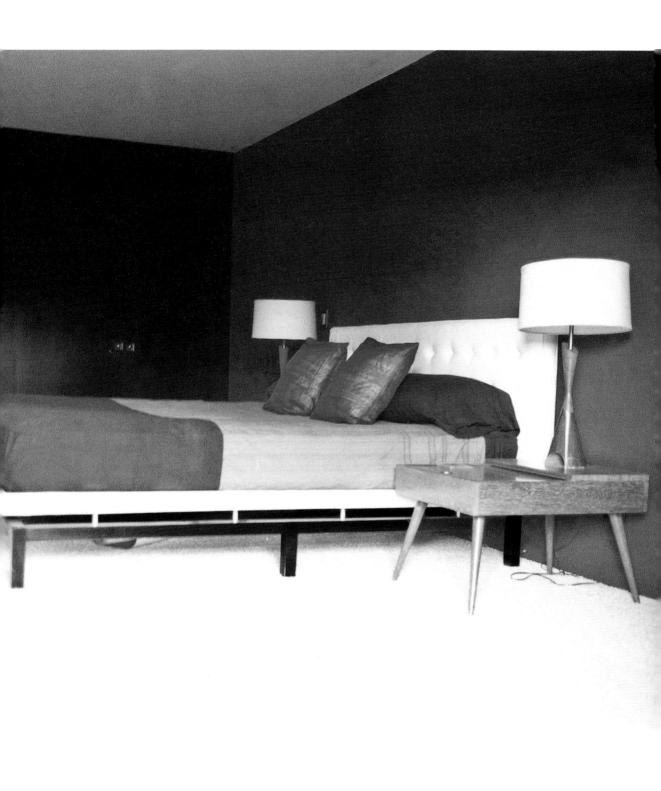

THE SHIP OF THE DESERT
Architects: Adrian Wilson & Earle Webster

The Ship of the Desert, designed by Adrian Wilson and Earle Webster, heralded the era of modern villas in Palm Springs when it was constructed in 1936. Located on a sublime piece of desert with tapering lines and a steamship silhouette, this residence features a cutting-edge architectural design that is punctuated by the work of interior decorator Honor Easton and landscape designers Fred Barlow Jr. and Katherine Bashford. Anchored to the heights of Palm Springs, this home is still the envy of all. Its panoramic views are exceptional, and living in the Ship of the Desert is like spending every day on a summer cruise in the middle of the desert—a privilege accorded to current owners Trina Turk, a fashion designer, and Jonathan Skow, a photographer.

Trina lets us in on the secrets of her house: "The house was built for a family, the Davidsons, from

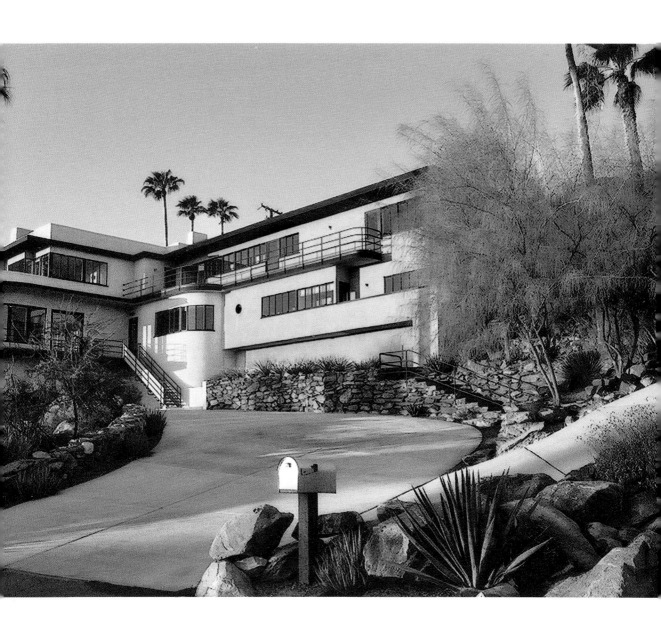

Washington, D.C. It was featured on the cover of *Sunset Magazine* in October 1937 in an article mainly about built-in furniture and the concept of designing furniture as part of the house. All of the larger rooms have windows on more than one side; some have windows on as many as three sides, and many rooms open out onto decks or patios. The upstairs bedrooms can only be accessed by an outdoor hallway, which is constructed like a ship's deck. The house's other distinguishing feature are counterweighted windows in the living room, which descend into the foundation of the house. When those windows and the pocket doors are open, the living room becomes very 'indoor/outdoor.' When the house was built, there was not much in Palm Springs. Catherine Meyler's house—the Miller House—is one of the only other early modern houses that still exists. The photos from 1937 show bare desert beyond the house, without palm trees or anything.

Webster and Wilson, the architects, had mainly worked in the L.A. area. We know of one other house in Pasadena that they designed; there could be many, but we have only seen photos of one. Webster and Wilson also designed Chinatown in downtown L.A., and Adrian Wilson worked on a housing project in Los Angeles called Pueblo Del Rio; it was a collaboration between Richard Neutra, Paul Williams, and Adrian Wilson. We also know that Adrian Wilson worked on the L.A. County Courthouse."

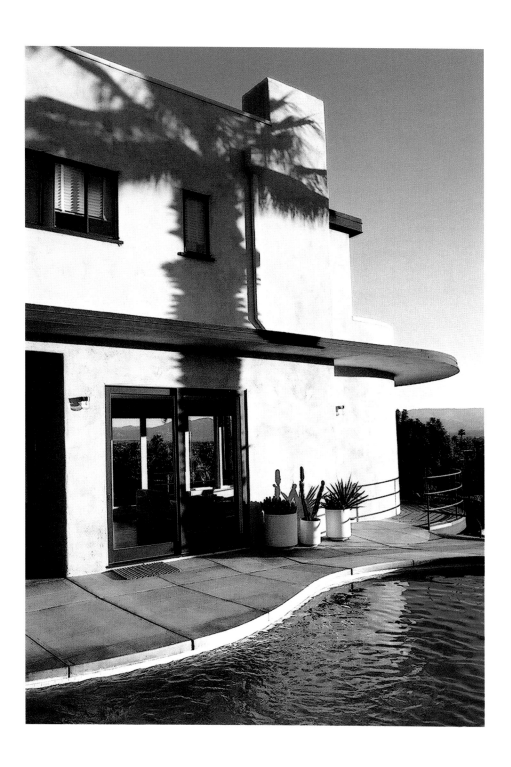

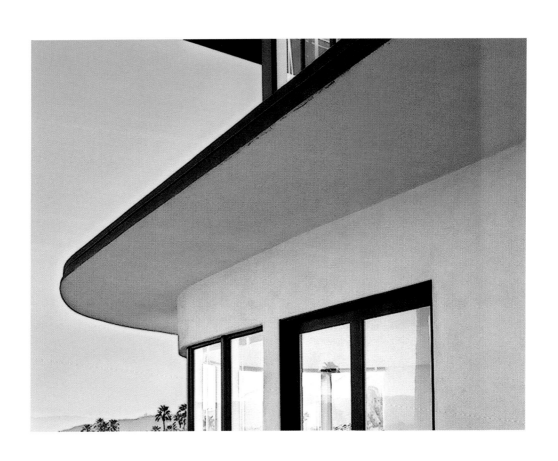

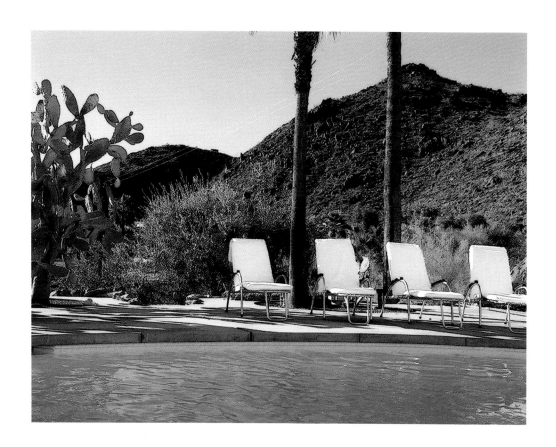

BOUGAIN VILLA

Architects: William Burgess & Albert Frey

Last but not least, the William and Clara Burgess House or Bougain Villa, designed in several stages from 1945 to 1960 by William Burgess (plus a guest house built by Albert Frey), dominates the Coachella Valley like an eagle's nest from atop the San Jacinto Mountains. Its chameleonlike glass and mirror walls change colors from dusk to dawn, reflecting the sky—crimson or azure—the mountains, and palm trees, all in infinite merging shades. As the house is made almost entirely of glass, the light is intensified and absorbed in gradations by dorsal walls that abut the rocky flanks of the mountains. These cool the villa in the summer and protect it from the cold winds of winter, acting as a temperature controller. Practically ethereal, Bougain Villa illuminates the landscape and the ultra-high-design custom furnishings that accessorize it. The fabulous collection of

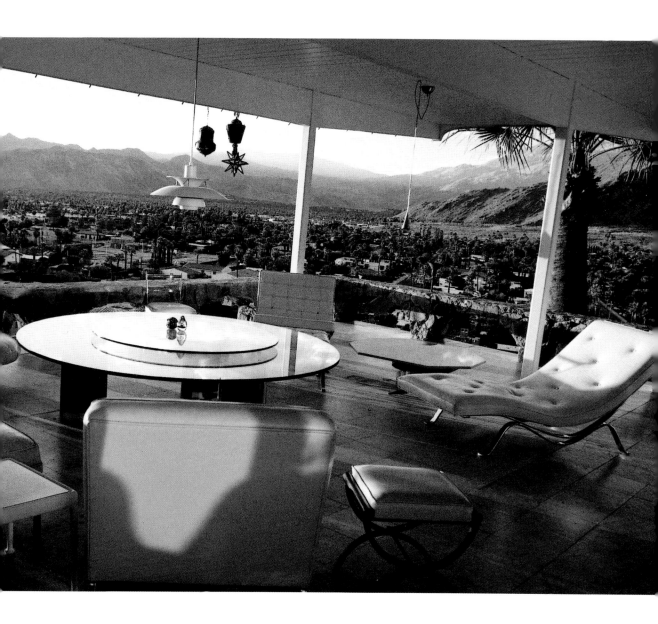

tables, sofas, and chairs designed by Bertoia, Laverne, McGuire, Platner, Mies van der Rohe, Eames, and Lenor Larsen give a tremendous cachet to the transparent architecture. Lighting fixtures designed by Noguchi, Poulsen, and Le Klint gently distill the starry nights. In the gardens, palm trees, orchids, bougainvillea, and mandarin orange trees color this piece of paradise balanced above Tahquitz Canyon Drive; and the artificial waterfalls, pools adorned with water lilies, and stepped pathways carved into the rock itself invite contemplation and wandering. Dorothy and Harold Meyerman came to the villa as an escape from Pasadena and New York. Enchanted by its magnetism, little by little, the couple made this extraordinary haven in Palm Springs their primary residence.

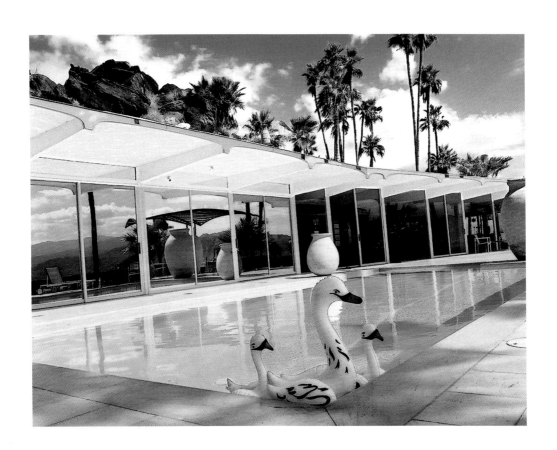

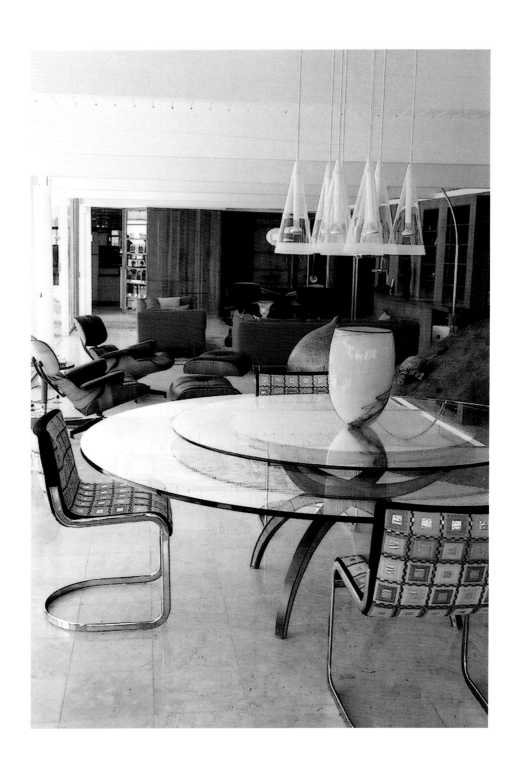

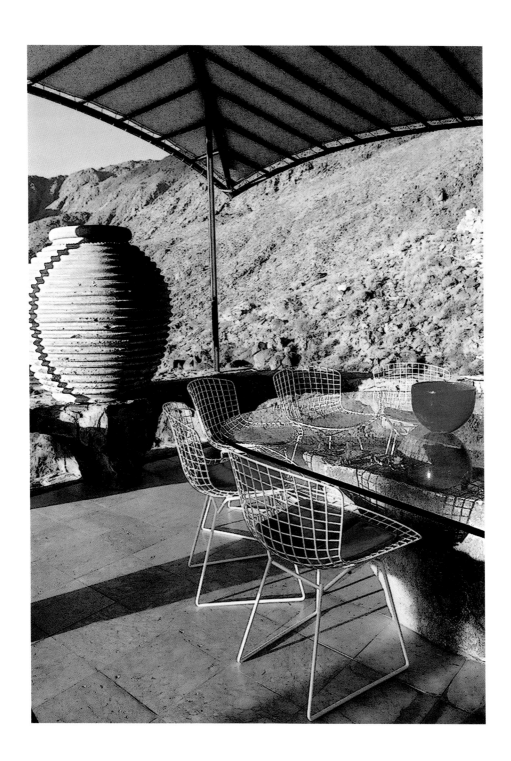

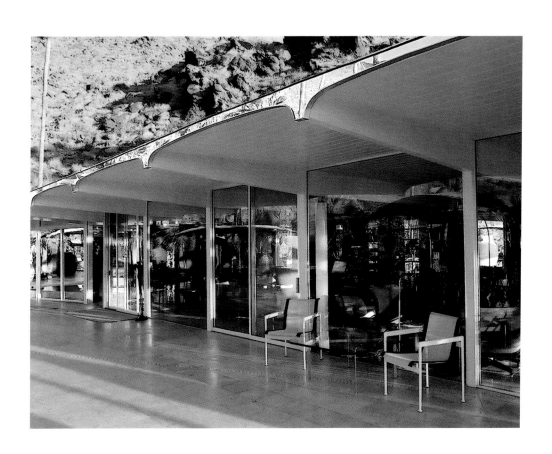

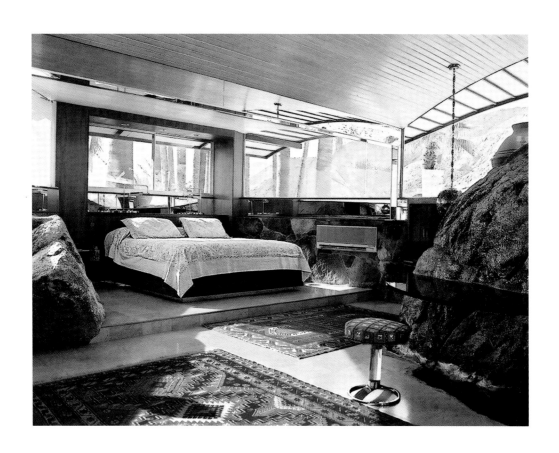

HOTELS

Hotels and country clubs are effective substitutes for experiencing Palm Springs without taking out a mortgage. In the '30s, stars like Clark Gable, John Wayne, and Spencer Tracy migrated to the Mirador Hotel; they swung at the Chi Chi Club, rode horses with Cary Grant at the Smoke Tree Ranch. The stars played tennis and tanned at the mythic Racquet Club with Frank Sinatra, met for dancing with Bing Crosby, John F. Kennedy and a host of young starlets at the Bamboo Bar, and took part in Sunday swimming with Johnny Weissmuller. Today the Mirador no longer exists, and the Racquet Club is deserted. But in Palm Springs, glamour holds up better than anywhere else. The rules of the game have not changed: sipping martinis poolside, playing tennis, and strolling the greens are all standard fare.

VICEROY PALM SPRINGS

Designed as a modern interpretation of the
Hollywood Regency style, the Viceroy Palm
Springs is a glamorous desert getaway featuring
private villas decorated by Kelly Wearstler,
manicured grounds, and three pools set amid
orange and grapefruit trees. Since the 1930s, the
Viceroy has defined the ultimate Palm Springs
resort experience, welcoming the likes of Clark
Gable and Joan Crawford. A fitness center,
guided walking and hiking trails, and PGA golf
courses complete the experience. We are fans of
Citrus, the on-premises gourmet restaurant and
cocktail lounge, the divine spa, which offers mas-
sages under ultra-chic tents, and the hot tub at
the foot of the mountains, which is best savored
immoderately on starry nights.

415 South Belardo Road; (760) 320-4117

www.viceroypalmsprings.com

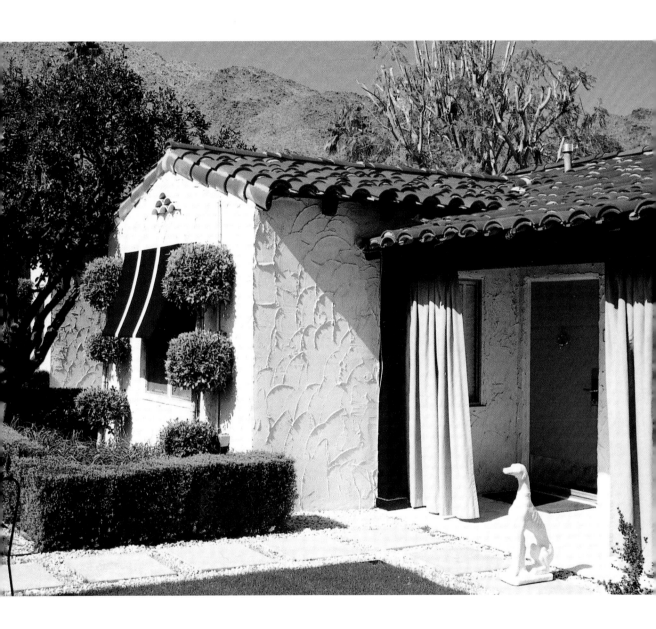

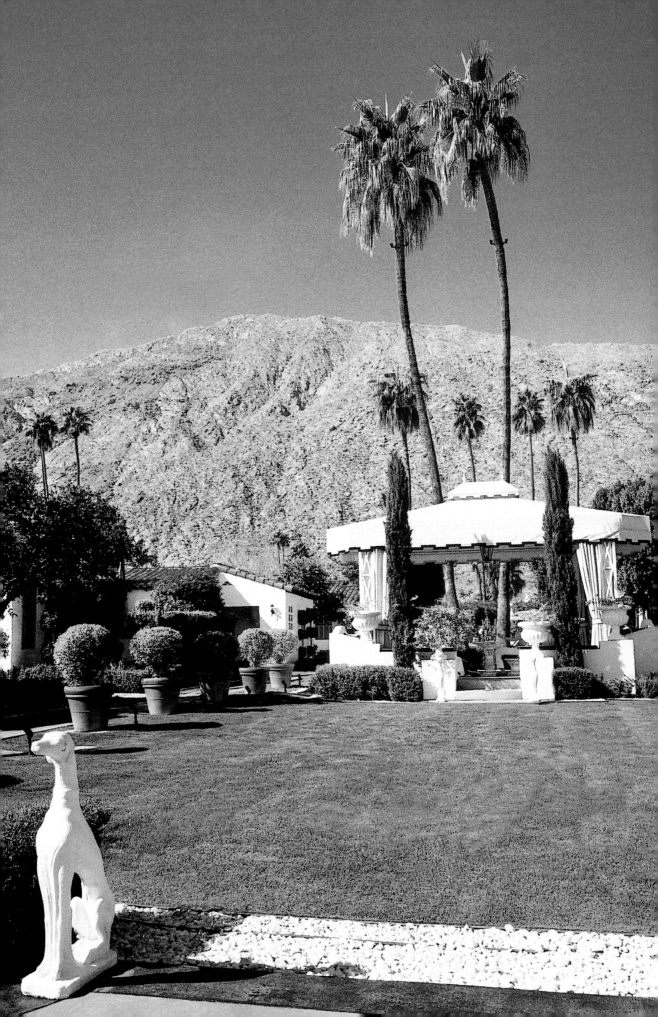

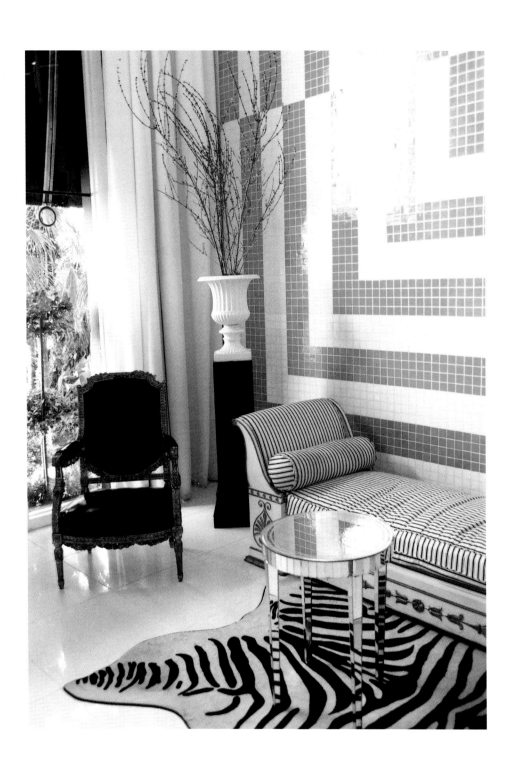

PARKER PALM SPRINGS
Architect: John K. Grist

From its debut as a Holiday Inn in 1959 to its former days as the Givenchy Resort & Spa, this designer hotel has found itself back in the limelight after a redesign by über-chic artisan Jonathan Adler. Inspired by the modern style and glamour of Palm Springs in its heyday, Adler has infused the hotel with charisma and flamboyant details, punctuating its interiors with color and the ecletic, from zebra-print rugs to geometric ceramics. Its lobby of the stars of the sixties and seventies, suites tennis courts, spa, lazulite swimming pool, oasis gardens, and terraced balconies are the stuff of dreams. Mister Parker's, the hotel's posh dining venue, is a destination onto itself.

4200 East Palm Canyon Drive; (760) 770-5000

www.theparkerpalmsprings.com

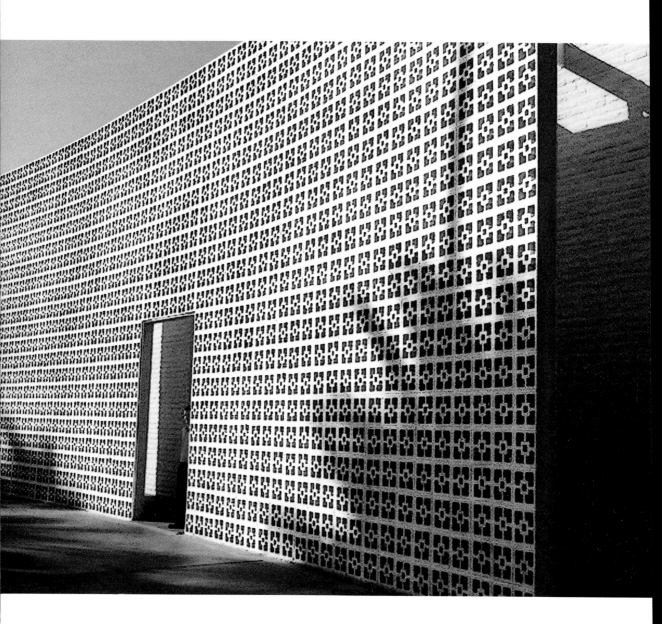

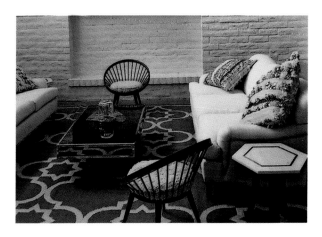

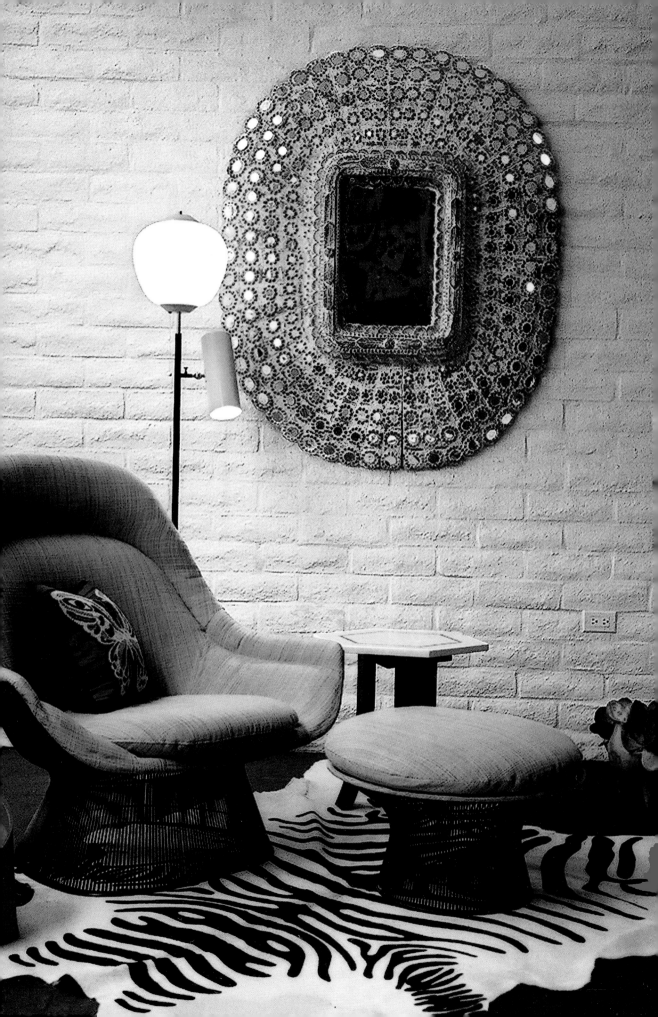

DEL MARCOS HOTEL
Architect: William F. Cody

The Del Marcos Hotel (1947) was the first opus of architect William F. Cody (1916–1978), who moved to Palm Springs from Beverly Hills. We love Cody's characteristically playful, deceivingly deconstructed structure, which calls into play hide-and-seek oblique walls, patios, corridors, and stairways. Restored and vintage-refurnished with enthusiasm and passion, this intimate sixteen-room hotel takes us back to the fifties on the flanks of the sublime San Jacinto Mountains and smack in the heart of Palm Springs. Choose suite 15, 16, or 19 on the second floor for their views and great comfort. And work on your tan to the rhythm of nostalgic hits under vintage umbrellas, with your toes dipped in the crystalline water.

225 West Baristo Road; (800) 676 1214

www.delmarcoshotel.com

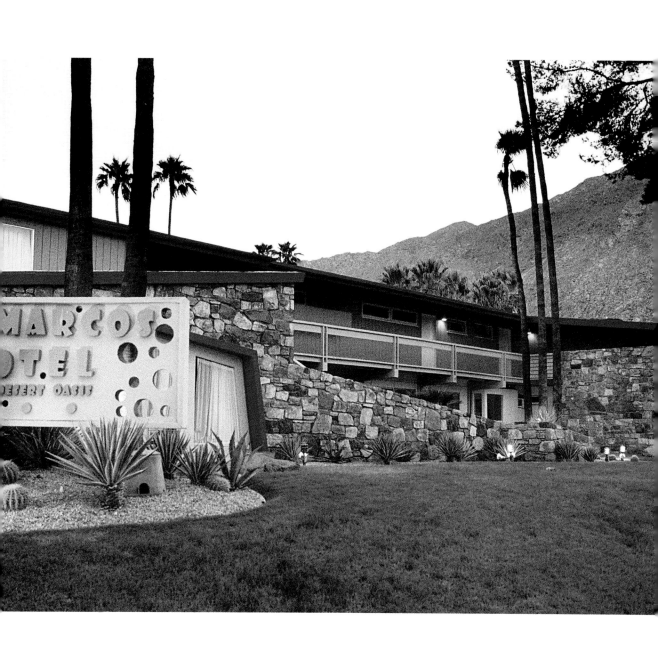

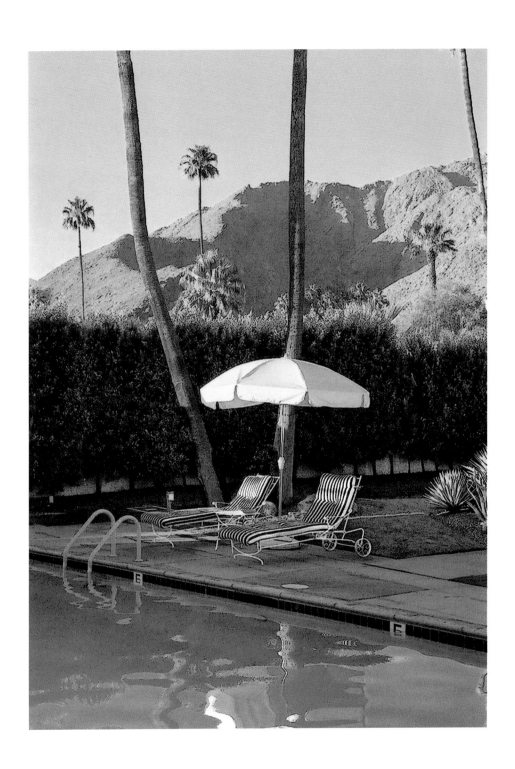

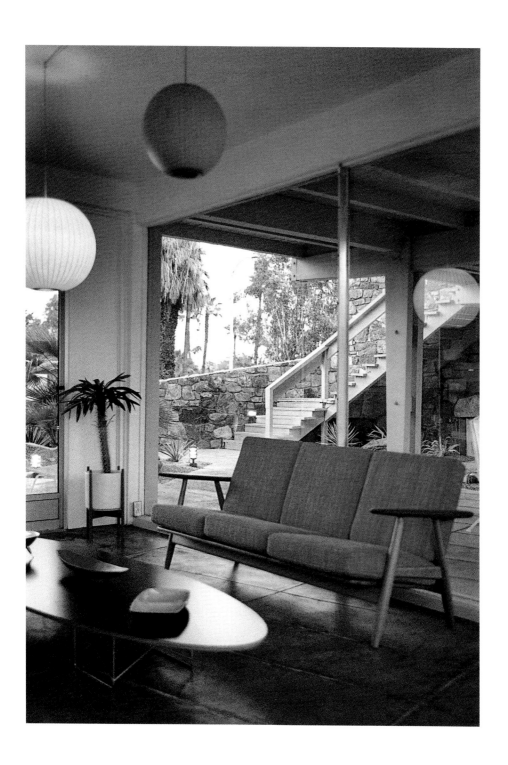

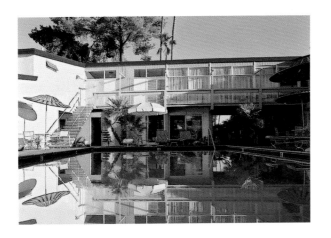

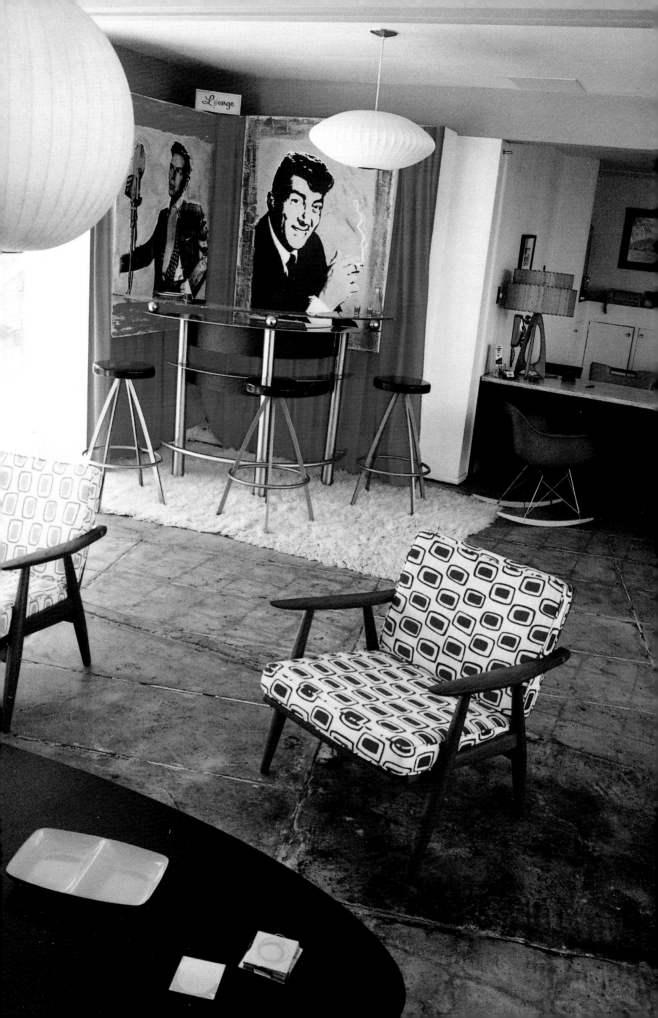

CALIENTE TROPICS RESORT

Architect: Ken Kimes

Reopened in March 2001 after an extensive renovation, Caliente Tropics is one of the last and greatest examples of the classic Polynesian-style motor hotels of the 1960s. This tiki playground now features spacious boutique-style guestrooms. The exterior has been made over to celebrate the original midcentury look when the resort opened in 1964. And we appreciate this little piece of the Polynesia set in the middle of the desert: a surrealistic oasis reminiscent of the American road movies of the sixties.

"Swim, relax and take in the extraordinary mountain views, in the warm light of the tiki torches, where Elvis hung out and Nancy Sinatra grew up," announces the establishment's flyer!

411 East Palm Canyon Drive; (760) 327 1391

www.calientetropics.com

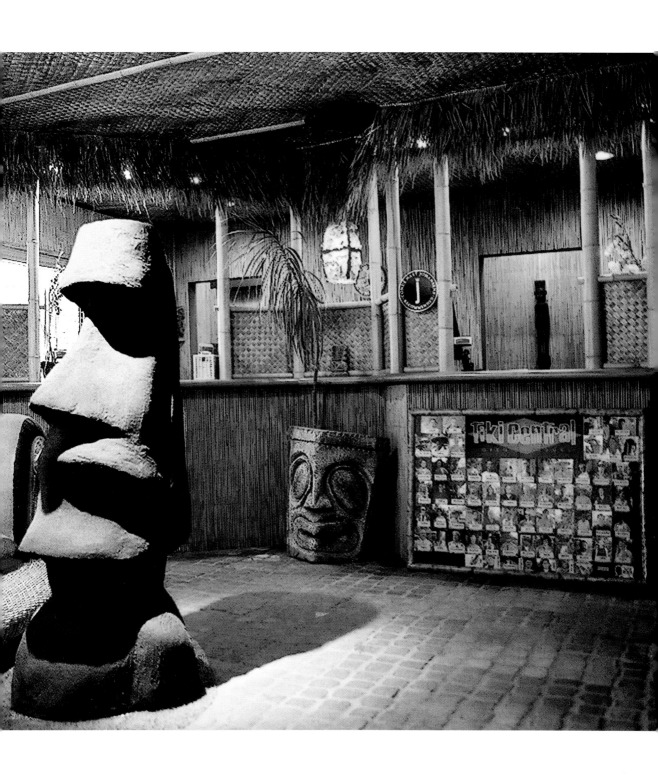

OCOTILLO LODGE
Architects: Dan Palmer & William Krisel

The Ocotillo Lodge, designed by Dan Palmer and William Krisel (1956), is a historic example of modern architecture. Unfortunately, the current hotel services and decor, redone in the standard, soulless chain style, do not make you want to stay there. However, its silhouette, bungalows, designer swimming pool, and hot tub are worth a look.

1111 East Palm Canyon Drive; (760) 416-0678

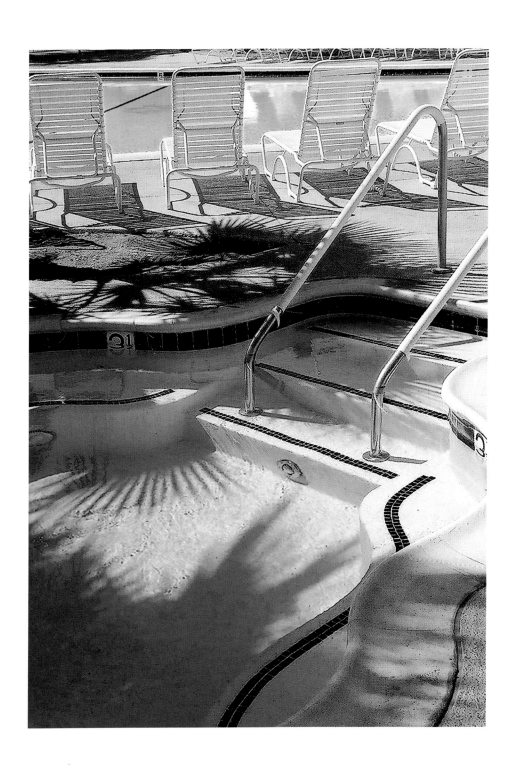

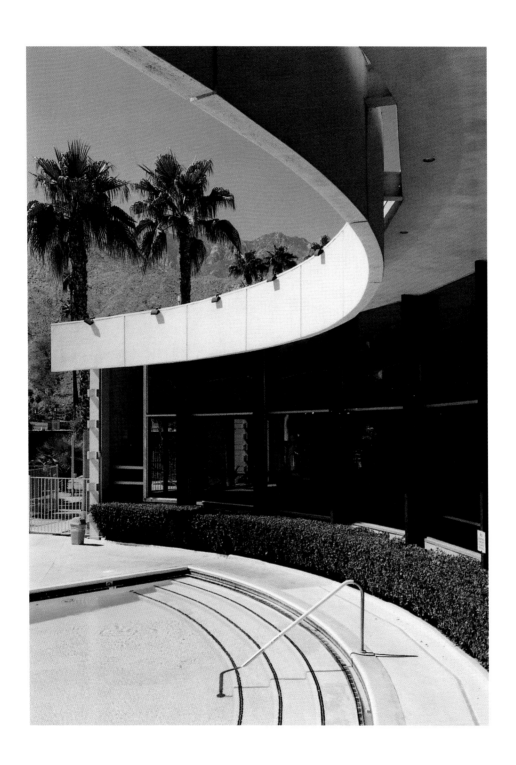

CONDOMINIUMS

The condominium is an innovative communal lifestyle concept (both in popular and high society) started in the 1950s-60s. Some of the first villas built on immense collective lots remain imprinted with modernism. Beautiful complexes still endure. These include the Park Imperial South Condominium, by Trudy Richards; the Edelstone Condominium; the Sandpiper Condominium; the Crown Pointe, Canyon View Estates, by Palmer & Krisel; the Royal Hawaiian, by Wexler & Harrison; Seven Lakes Country Club by Richard Harrison; with an original club house by William F. Cody.

And who better than Robert Imber,[1] owner of PS Modern Tours, specialist in mid-twentieth-century architecture, and resident of Seven Lakes Country Club (built between 1963 and 1973) to talk to us about this lifestyle:

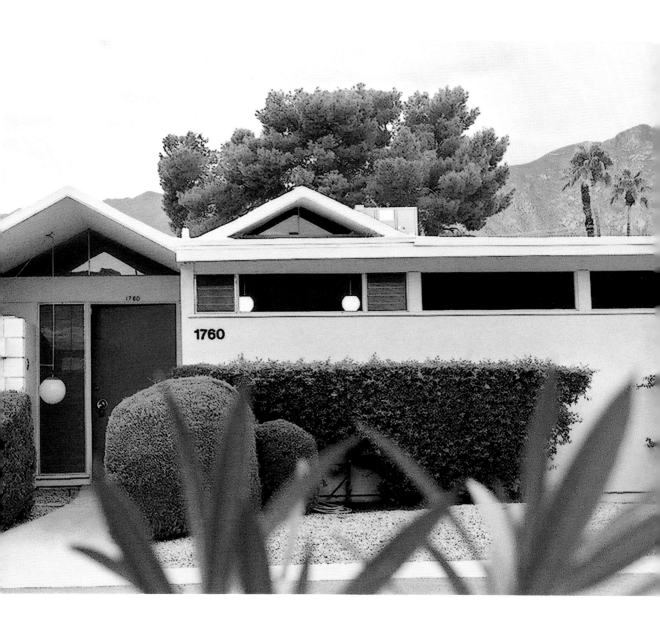

"Condominium is technically a real estate description and can differ slightly from region to region. Generally, it means that one purchases his or her own home but does not own the land or public areas surrounding it. A Homeowner's Association (HOA) is the governing body, with a group of board members voted to make decisions for the whole group on the owner's behalf. A condominium can be a small complex of just a few units, or a larger place like where I live with many decisions, rules and regulations, and departments (real estate, groundskeeping, architecture, finances, landscaping, roads and maintenance, painting of buildings, golf course, restaurant, tennis courts, pools, spas, etc.).

The condominium concept started in the 1950s, but didn't really gain hold until the 1960s and 1970s and much of it originated in California.

At the Seven Lakes condominium, the architecture and layout of the streets are beautifully representative of the modern era and provide a spacious, practical way of living. The architecture offers simple but sophisticated rectangular buildings made of custom designed and wonderfully patterned concrete block; very high ceilings; no unnecessary adornments; open and practical rectilinear floor plans; large, open rooms and wide expanses of glass walls and sliding doors; quality construction and luxury elements.

There are 350 condominiums at Seven Lakes with the majority of them only two to a building; back-to-back mirror-image floor plans in four different sizes. With broad mountains and endless sky above, each building is painted in the same off-white tone and rests on the vast green fairways of the golf course, creating an elegant, artistic pattern in the landscape. Each home includes a large private walled-in garden, including an outdoor gated entrance (different from the front door entrance) and opens to at least two rooms by large expanses of glass sliding doors and glass walls. The homes are spacious and situated to take advantage of the natural light, excellent golf-course views and spectacular mountain views.

There is an abundance of wildlife, so ducks and mallards are always walking or landing nearby, birds of all types abound, coyotes howl in the distance, an owl is often heard hooting late at night, doves are singing, and migrating monarch butterflies and birds always spend some time here en route to their winter homes elsewhere.

And it is easy to lock the door, leave for an extended time and know everything will be kept safely. There are many, 'seasonal' owners at Seven Lakes (as in most Palm Springs condominiums or country clubs with homes on the grounds) who have homes in other places such as Canada and the Pacific Northwest (Oregon, Washington, etc.)."

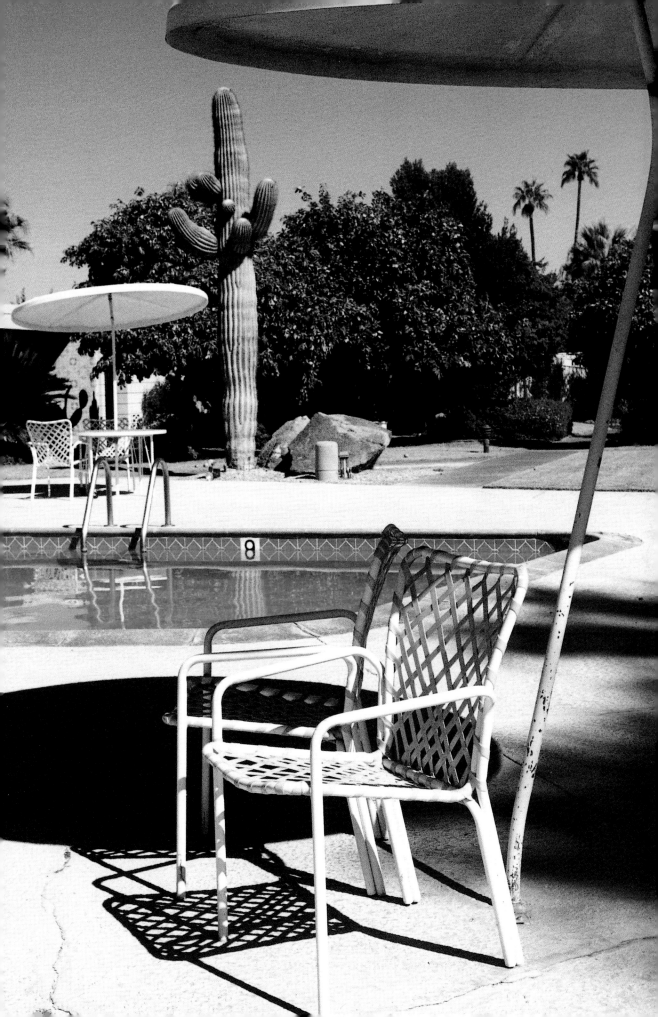

Renowned American architecture expert Anthony Merchell has given us his comments on the two condominiums photographed for this volume:

The Park Imperial South Condominium (1961)[2] is a lovely, simple, well-designed condominium with terrazzo floors, glass walls, a bar made of square concrete blocks, private patios, and a zigzag roof. The 1760 unit also has the original turquoise-colored electric appliances, and a space-age metal vent hood. An excellent example of good modern design on a small scale. The folded plate roofline is a noteworthy character-defining feature typical of the early 1960s.

The Sandpiper Condominium[3] (1958, designed by Palmer & Krisel) was conceived as a luxury condominium with resort hotel services such as maids and room service. The units were intended as second homes for use in the winter season. Each single-story structure contained three units in a pinwheel-shaped plan. Eight structures were then built around a communal pool area. This presented an intimacy of scale, while providing excellent views. Although the overall design was standardized, certain elements were varied to provide uniqueness. Ceilings could vary in height. The concrete block walls would have different patterns, heights, and angles. Customized dimensional blocks were designed by

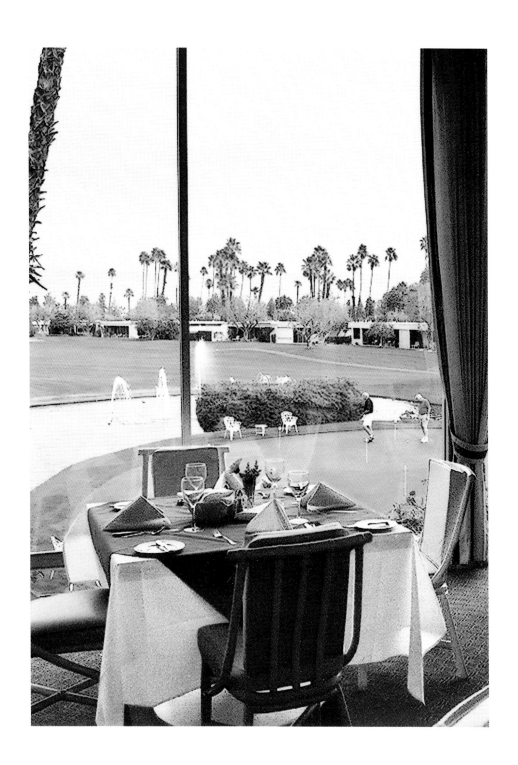

Palmer and Krisel to supplement the standard block. The site planning was important. Original landscape contours were maintained. This reduced site preparation cost, but also provided a range of views. Concrete block steps were used to transition the site elevations. These steps, used in both a straight line and an angled orientation, contrast nicely with the mountain backdrop. For his work on the Sandpaper Condomiunium, Bill Krisel, who is also a landscape architect, developed a full landscape plan that would lead to his receiving a Landscaping Merit Award for Sandpiper.

1. Owner of PS Modern Tours.
2. 11760 Araby Drive (developer: Trudy Richards).
3. Corner of Highway 74, El Paseo, Palm Desert.

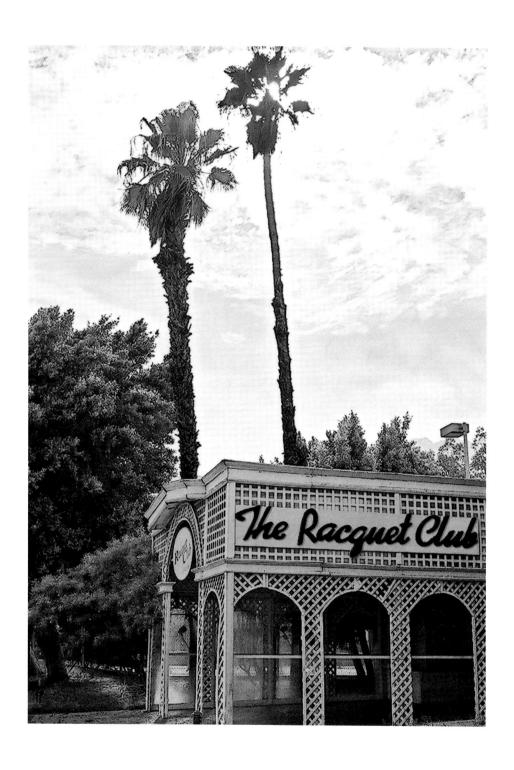

PALM SPRINGS ART MUSEUM

Architect: Stewart Williams

Stewart Williams, the designer of several compounds in Palm Springs, including the Frank Sinatra House and the Kenaston House, was the architect of the Palm Springs Desert Museum (nowadays known as the Palm Springs Art Museum). In an interview at his home at the Seven Lakes Country Club, he spoke about his signature project: "Architects brought modernism to the desert. I attempted to bring the desert to modernism and my architecture; its strength, its energy, its intrinsic beauty, its magic, its materials, its texture, its lights, its morphology."

Exhausted by his ninety-five years, but his gaze still luminous, Stew is madly in love with Palm Springs. "It's both marvelous and very difficult to build in such a setting," he says. And it's particularly difficult to evoke the majestic San Jacinto Mountains, the imperturbably blue sky

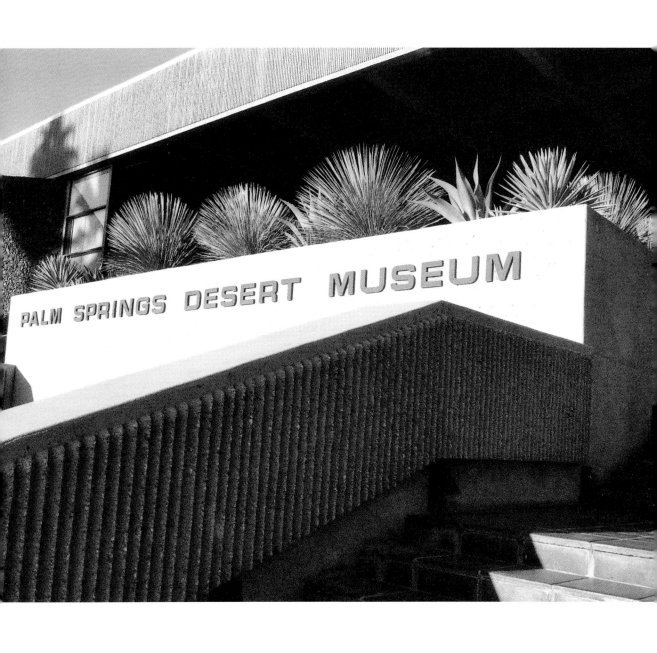

that emanates the intense light that he analyzed, playing with its diffraction, refraction, reflection, and inflection in subtle effects of texture and shadow. Like the channels furrowed in the walls of the museum or the floating monoliths, casting elegant and refined shadows. "I like to use earth colors so as not to dazzle the eyes in this overexposed context," Williams explains. He traveled nearly all of the deserts of California and Arizona to find the ideal material to coat the exterior of the Palm Springs Art Museum: "volcanic rock with hints of cinnamon, anthracite, burnt sienna, and amber…in total harmony with this exceptional site. Inside, I opted for the neutral tones of concrete, which sets off the artworks. One must recognize and respect the strength of nature's design—that is essential—and work according to the dictates of the project. Here, that meant enthroning the dignity of this institution and illuminating the exposed artworks." And greeting us, humble and passionate, admitting that he is not fond of the works of Frank Gehry, preferring instead his design masters Ludwig Mies van der Rohe, Eero Saarinen, and Richard Neutra.

101 Museum Drive; (760) 325-7186

www.psmuseum.org

Bill Butler's house designed by William F. Cody.

REVIVAL
OF THE MODERN

Though it may be the case that the first jewels of modernism in Palm Springs are now hidden amid urban developments of questionable taste, it is precisely this intermingling that is so well suited to a new generation of aesthetes who follow their own itineraries through Las Palmas Heights, Little Tuscany, the narrow streets of Sunrise Park, Sunset Road, Tamarisk Drive, and Vista Chino behind the wheel of an old Chrysler or Cadillac convertible.

The city's return to grace is a recent phenomenon. In the 1980s and '90s, Palm Springs drowsed, with the majority of its residents consisting of retirees

from all over the country. They came to tan beneath the winter sun and spend their days on putting greens and in the offices of plastic surgeons. Modernism was gradually drowning in the midst of a profusion of country clubs, new pseudo-Spanish colonial villas, and the tawdry '80s style. It was to the credit of aesthetes such as Jim Moore, the creative director of *GQ* who, in 1993, acquired a modern residence designed by Wexler, that Palm Springs was rediscovered. Photo shoots by some of the biggest names in fashion photography, from Mario Testino to Herb Ritts, followed, spreading the magic light of Palm Springs globally. And word of mouth did the rest.

Today stars are once again rushing to Palm Springs—for the silence of the desert, its space, natural beauty, architecture, and timeless aesthetic. Marilyn Monroe, Frank Sinatra, Jayne Mansfield,all of whom once contributed to the glamour of the city, are now replaced by the new hollywood icons.

Richard Neutra's Kaufmann House was the backdrop for a Ralph Lauren campaign shot by Bruce Weber; Nicholas Cassavetes wrapped up a hush-hush shoot in the city; *Vanity Fair* snapped Julianne Moore for its cover; and *Elle* captured Scarlett Johansson on the heights of Palisades Drive in a residence designed by Albert Frey. And Kirk Douglas, a longtime resident, has just agreed to bequeath his name to a street in this paradise.

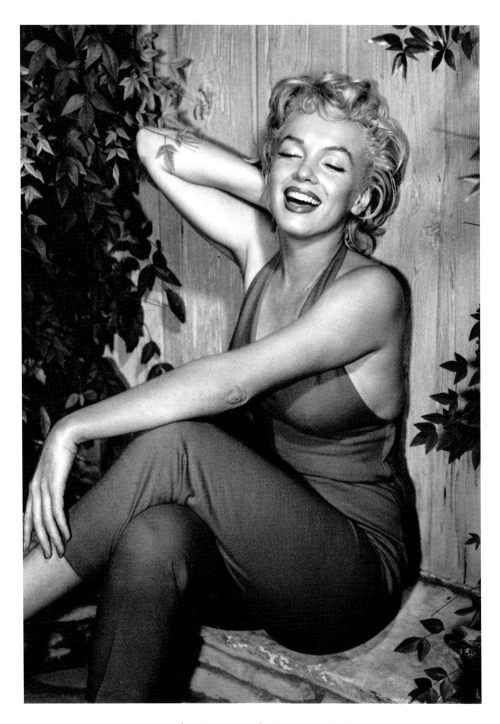

Marilyn Monroe, Palm Springs, 1954.

Modernism has moved Palm Springs into a new era; the city has become a historic referent, like an art form. The Palm Springs Art Museum, known for its collections of contemporary art, photographs of Hollywood in its heyday, Central American art, and art and artifacts from African and Western cultures, has just opened a branch dedicated to twenty-first-century architecture and design. This institutional sanctioning anchors and transcends the myth of this city.

Modern villas have become the new status symbol, much like sought-after works of art. Everyone wants to own a Neutra, a Williams, a Wexler, a Lautner... These are the status symbols—or even the accessories—of the moment, and in some social circles it's not enough to own just one. But the residences are increasingly difficult to come by, not to mention that their purchase prices are preclusive. (Some owners seek to profit from their assets, leasing their properties for photo shoots, film shoots, or even parties.) The structures are iconic, and the interior decor is exemplary, as most of these fortunate owners are purists who never stop restoring their residences. Design is a point of honor for these indefatigable hunters of furniture and objects, and some of the most prominent vintage galleries have moved to Palm Springs accordingly. Residences are preserved, restored, and sometimes exhibited for exclusive showings arranged by private foundations. At these showings, groupies contemplate carefully preserved original

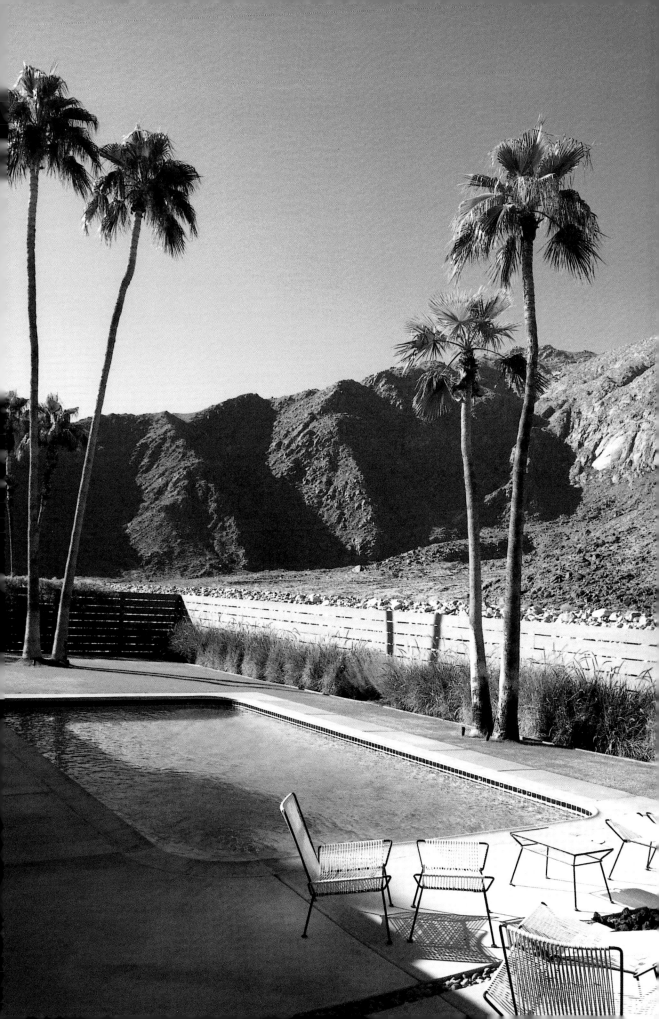

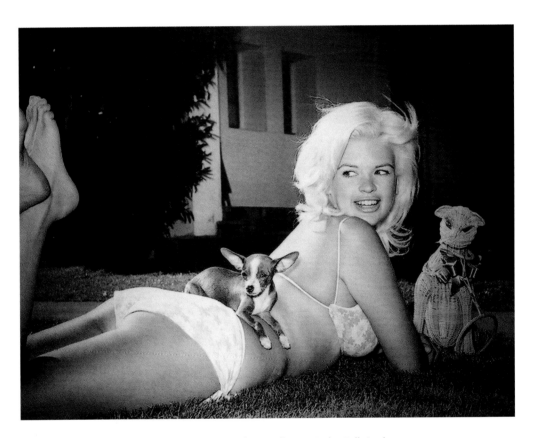

Jayne Mansfield, November 20th 1960, by Bill Anderson.

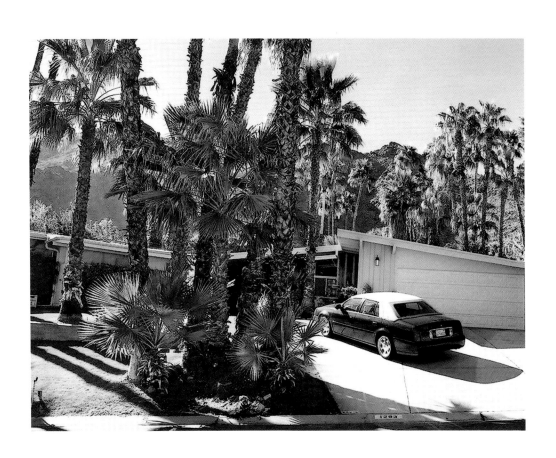

drawings and vintage furnishings designed by the greats: Charles and Ray Eames, Harry Bertoia, Achille Castiglioni, Henrik Van Keppel, Eero Saarinen, Warren Platner, and Richard Schultz.

An indefinable aura pervades not only the interior of a Palm Springs residence, but also the exterior. A residence's gardens—an integral part of the home—are generally maintained and restored according to the original drawings by creative talents such as William Kolpek, of the modern landscaping company Inside/Outside. (For example, Kolpek restored a part of the Kaufmann House gardens, designed by Richard Neutra in 1946, using original photos taken by Julius Shulman.) Kolpek also creates inspired custom landscapes for the fortunate owners of vintage villas. It is not unusual to see enormous trucks transporting boulders, palm trees, and even immense cacti to be implanted with cranes.

Two pioneering committees in Palm Springs, the Palm Springs Modern Committee (PSMODCOM) and the Palm Springs Preservation Foundation (PSPF), implement a policy of promotion, preservation, and restoration. Both are committed to preserving the town's architectural heritage with a focus on the modern era (particularly in the case of PSMODCOM). With the passionate support of their members, the two groups are primarily focused on identifying historic sites and protecting against plans for their demolition, such as

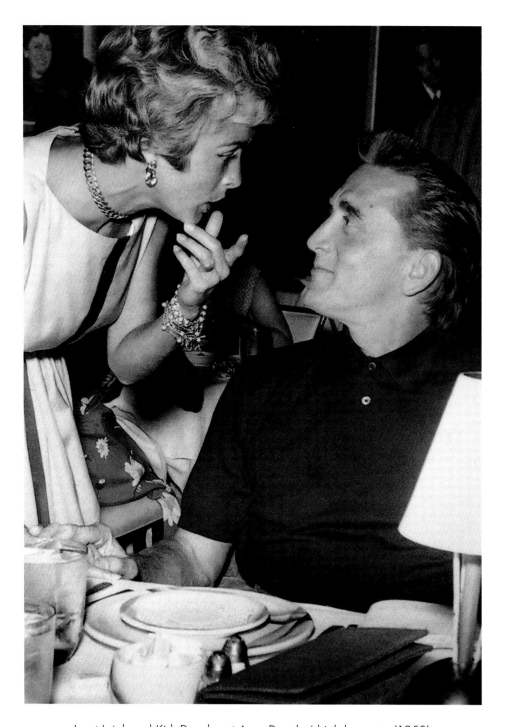

Janet Leigh and Kirk Douglas at Anne Douglas' birthday party (1953).

the 1999 proposal to eradicate a fire station designed by Albert Frey in 1955. As a direct result of the committee's efforts, petitions were circulated and the site was classified as a historic landmark.

Moreover, the committees remain on high alert as the success of Palm Springs draws developers who flock to the oasis hoping to colonize the flanks of the San Jacinto Mountains. Will this authentic setting of modernism be transformed into overcrowded subdivisions? Billboards that herald SAVE PALM SPRINGS look down on the epicenter of the town as a historical register, excellence awards for site restoration, grants for restoration work, and even local tax incentives support the city's vulnerable heritage. Panel discussions, meetings, and an annual show bring international fans of modernism together. Architectural historian Anthony Merchell has devised a map showing most of the modern sites in Palm Springs. An archive of modern times for some and a rite of initiation for others, international fans peruse it with fervor during their visits, or take the enlightening tours given by modernism specialist Robert Imber, who shares his knowledge with gusto. Palm Springs, the conspicuous beauty, is a new legend—thanks to its design treasures.

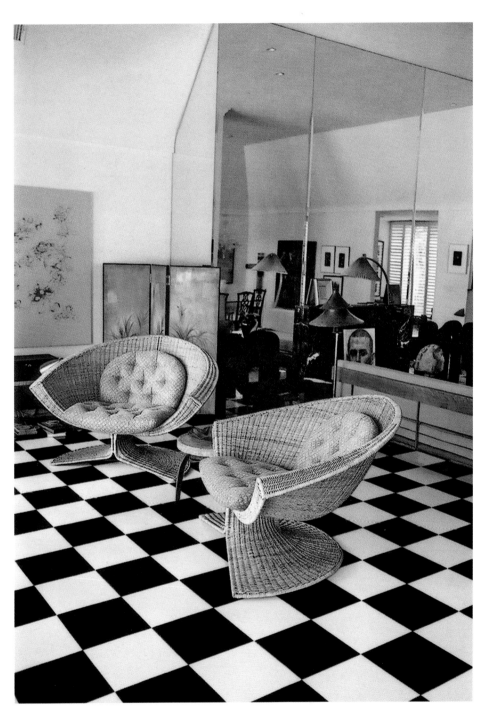

Bill Butler's house. Miller Fong *Lotus* Chairs (1968);
painting at left by Emilio Perez (1999).

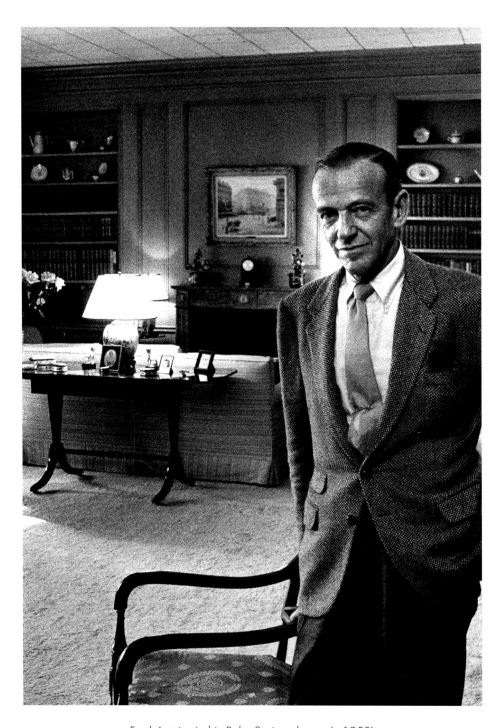

Fred Astaire in his Palm Springs house (c.1950).

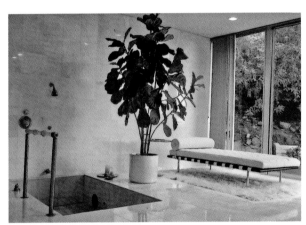

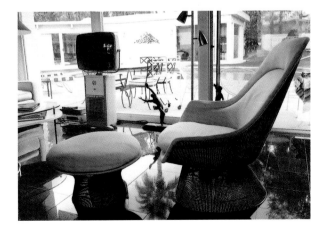

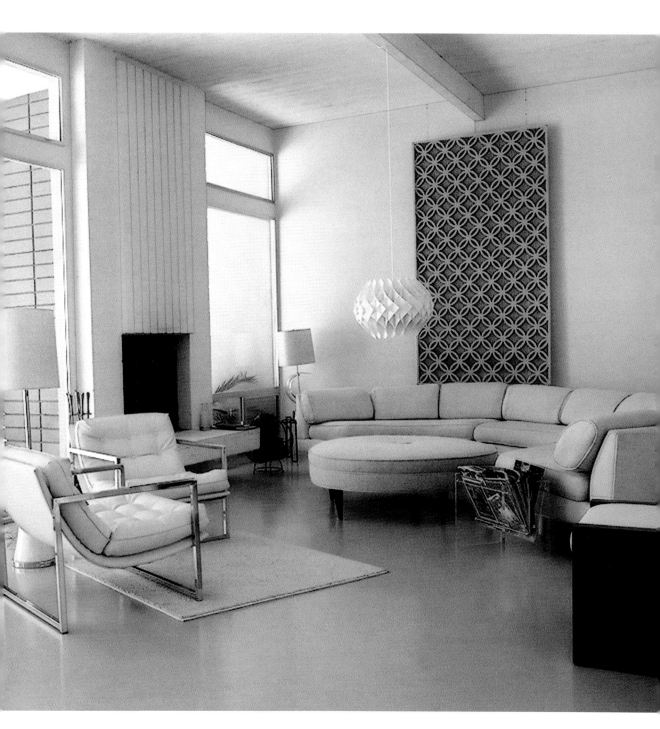

Alexander House by Krisel and Palmer
redesigned to capture the 1950's era glamour.

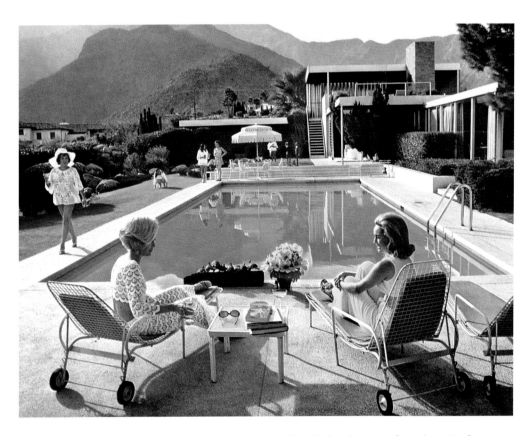

The famed Desert House in Palm Springs designed by Richard Neutra for Edgar Kaufman. Lita Baron approaches Nelda Linsk (right), (wife of Joseph Linsk, the famous Palm Springs art dealer) and a friend, Helen Dzo Dzo.

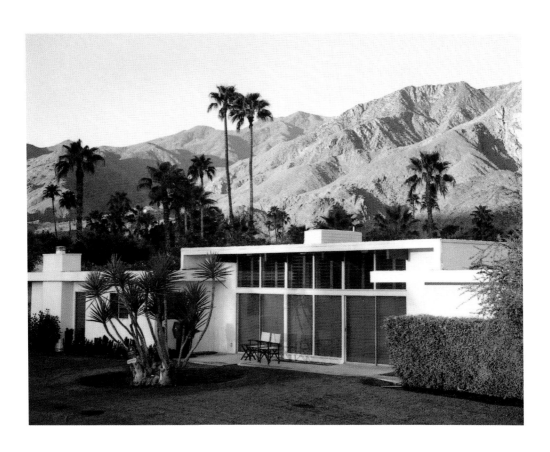

ADDRESS BOOK

● SHOPPING FOR VINTAGE FURNISHINGS AND MODERN OBJECTS

North Palm Canyon Drive is the best street to find all our favorite shops and designers, including Eames, Nelson, Day, Bertoia, Schultz, Cardin, and Zanuso.

Galleria, 457 N. Palm Canyon Drive, (760) 323-4576

Retrospect, 666 N. Palm Canyon Drive, (760) 416-1766

Galaxy 500, 1007 N. Palm Canyon Drive, (760) 320-7776

Mod Springs, 1035 N. Palm Canyon Drive, (760) 327-5400

Dazzles, 1117 N. Palm Canyon Drive, (760) 327-1446

Modern Way, 2755 N. Palm Canyon Drive, (760) 320-5455; www.psmodernway.com

Palm Springs Consignment, 497 N. Indian Canyon Drive, (760) 416-0704

Vintage Oasis, 373 S. Palm Canyon Drive, Studio A, (760) 778-6224

In February, visit an important vintage design event, the Palm Springs Modernism Exhibition and Sale; www.palmspringsmodernism.com

● MANDATORY

Discover the modern architecture of Palm Springs with a guided visit by Robert Imber. This fascinating enthusiast takes you to all the best addresses. Palm Springs Modern Tours, (760) 318-6118; psmoderntours@aol.com

● INFORMATION CENTER

Experience a hike through Tahquitz Canyon or Joshua Tree National Park, go flying in a glider or a hot air balloon, or take a celebrity tour and see where Marilyn Monroe slept; www.celebrity-tours.com

In addition, browse through the center's interesting selection of literature and maps of Palm Springs, 2901 N. Palm Canyon Drive, (760) 778-8418; www.palm-springs.org

● THINGS TO KNOW

Today Palm Springs encompasses a conglomerate of different areas that have developed around the original downtown. This volume focuses only on downtown Palm Springs, the original urban area, and soul of the Hollywood glamour era and of modernism, not to be confused with Indio, La Quinta, Indian Wells, Palm Desert, Rancho Mirage, or Cathedral City, which are all situated along Route 111.

● PRESERVE MODERN ARCHITECTURE

The Palm Springs Modern Committee holds open-house weekends at compounds and runs preservation and restoration campaigns; www.psmodcom.com

The Palm Springs Preservation Foundation registers and protects modern architecture as international heritage sites; www.pspf.net

● RENT A VILLA

Lease an iconic villa for a photo shoot, film, or party, or even to fulfill a dream for a few hours or a few days; www.vrbo.com; www.palm-springsrental.com;www.vacationpalmsprings.com. Catherine Meyler's Meyler & Company is the reference standard for high-profile photography, film, and advertising. The major players continually invest in the sites discovered by this agent, who is always uncovering fantastic locations: www.meylerandco.com

● FALL IN LOVE

The Aerial Tramway Station, designed by Frey and Williams, is suspended more than 29,000 feet above the San Jacinto Mountains, which are snowcapped in winter. After a fifteen-minute climb aboard an immense 360-degree rotating gondola car, you reach a sublime panorama. There, you can grab a bite to eat in the cafeteria at the top; the view overlooking the various hiking trails is worthy of a Martin Parr postcard. The access road, just ten minutes from downtown Palm Springs by car, is equally splendid; www.pstramway.com

Tyler's is the local favorite for the best juicy burgers, shakes, and lemonade. La Plaza, 149 St. Indian Drive, (760) 325-2990.

Absolute musts, the restaurants of: Viceroy (www.viceroypalmsprings.com), Parker Palm Springs (www.theparkerpalmsprings.com), Johannes (www.johannesrestaurant.com, fusion), Le Vallauris (www.levallauris.com, French touch), Zin American Bistro (www.zinamericanbis-tro.com, cafe style), Spencer's (Palm Springs Tennis Club, www.spencersrestaurant.com), Melvyn's (www.inglesideinn.com, nostalgic).

For an escape in the heart of the desert, La Quinta Resort (www.laquintaresort.com) where Garbo slept, and El Paseo Avenue in Palm Desert, one of the trendiest spots for shopping and casual and chic restaurants.

Polo matches in the casual chic-atmosphere of the El Dorado Polo Club, 50950 Madison Street, Indio, (760) 342-2223; www.eldoradopolo.com

● DRESS CODE

Los Angeles fashion designer Trina Turk, who spends long weekends at her historic residence, the Ship of the Desert, designed by Adrian Wilson and Earle Webster, sets the standard for Palm Springs style. Several years ago, she acquired a boutique on North Palm Canyon Drive, in a building designed by Albert Frey, and her fashions worn by the likes of Julianne Moore, Gwyneth Paltrow, Courtney Cox, and Kate Moss have been extremely successful here. Don't

miss her nostalgic and glamorous collections, which evoke Palm Springs' golden age. 891 N. Palm Canyon Drive, (760) 416-2856; www.trinaturk.com

● HOTELS

The Desert Hot Springs Motel (architect: John Lautner, 1947)

Not photographed for this volume—it is situated outside of Palm Springs proper—the Desert Hot Springs Motel must nevertheless be mentioned as a veritable gem designed by John Lautner in 1947. A visit to the hotel is a magical experience for aficionados of modernism.

To get there, take I-10 to the Palm Drive exit, head north on Palm to Camino Aventura (there is a sign that says welcome to Desert Hot Springs on that corner). Turn right (east) on Camino Aventura, drive to Yerxa, turn left on Yerxa. Take Yerxa to San Antonio. The motel is on the far left corner. (760) 288-2280; www.lautnermotel.com

Other lovely, intimate, designer accommodations include:

7 Springs, 950 N. Indian Canyon Drive, (800) 381-0684; www.7springs.info

Movie Colony Hotel, designed by architect Albert Frey in 1935, 726 N. Indian Canyon Drive, (888) 953-5700; www.moviecolonyhotel.com

Orbit Inn, designed by Herbert Burns in 1957, 562 W. Arenas, (877) 996-7248; www.orbitinn.com

● SELECTION OF MODERN SITES

Institutional, commercial, religious, and residential:

Tramway Gas Station, now the City of Palm Springs Official Visitor Information and Reservation Center, by Albert Frey and Robson C. Chambers (1965). 2901 N. Palm Canyon Drive, (760) 778-8418

City National Bank, now Bank of America (1959), by Victor Gruen Associates and Rudy Baumfeld. 588 S. Palm Canyon Drive

St. Theresa Catholic Church, by William F. Cody (1968). 2800 East Ramon Road

Palm Springs City Hall, by Albert Frey, John Porter Clark, and Robson Chambers (1952–1957). 3200 E. Tahquitz Canyon Way, (760) 323-8299

Coachella Valley Savings and Loan Association, by Stewart Williams (1960). 499 S. Palm Canyon Drive

Palm Springs Tennis Club, by A. Quincy Jones and Paul R. Williams (1947). 701 W. Baristo Road

Robinson's Department Store, by Pereira and Luckman (1958). 333 S. Palm Canyon Drive

Palm Springs Spa, Resort, and Casino by William F. Cody (1961). 100 N. Indian Canyon Way,

(760) 325-1461

Racquet Club, by Albert Frey (1945). 2743 N. Indian Canyon Drive

Horizon Hotel, by William Cody (1953, currently being restored). 1050 East Palm Canyon Drive, (760) 323-1858; www.thehorizonhotel.com

Steel Houses, by Donald Wexler (1961). Sunny View Drive, Simms and Molino Roads.

● BOARDING PASS

To get to Palm Springs, Jet Blue offers direct service to Ontario Airport. Other airline services: Alaska Airlines, American Airlines, America West, Delta/Skywest, United Airlines, and USAir Express.

● DIRECTIONS

From Los Angeles (1 hour and 45 minutes):

* Take Interstate 10 east, approximately 110 miles
* Take CA-111 to Palm Springs
* CA-111 becomes Palm Canyon Drive, the one-way main street in the center of town

From San Diego (2 hours and 15 minutes):

* Take Interstate 15 north
* Take Interstate 215 north
* Take the Freeway 60 east (to Indio/Palm Springs)
* The Freeway 60 runs into Interstate 10 east
* Take CA-111 to Palm Springs

From Ontario (1 hour and 15 minutes):

* Take Interstate 10 east (to Redlands/Indio), approximately 55 miles
* Take CA-111 to Palm Springs

From Orange County (1 hour and 40 minutes):

* Take the Freeway 91 east (to Riverside)
* Take the 60 Freeway east (to Indio/Palm Springs)
* The 60 Freeway runs into Interstate 10 east
* Take CA-111 to Palm Springs

ARCHITECTS
Residents of Palm Springs

● **WILLIAM F. CODY (BY A. MERCHELL)**

Born 1916 in Dayton, Ohio. Educated at the University of Southern California, where he worked for the architect Cliff May. Moved to Palm Springs and built his first project: the Del Marcos (now San Marino) Hotel, in 1946. Converted the Thunderbird Dude Ranch to the Thunderbird Country Club, which led to his later designs of the Tamarisk and the El Dorado country clubs. Designer of the Spa Hotel and a wide variety of commercial and residential projects in Palm Springs, Phoenix, San Diego, Palo Alto, and Havana. Designed the Palm Springs Library Center and St. Theresa Catholic Church prior to suffering a stroke that ended his architectural career.

● **ARTHUR ELROD, INTERIOR DESIGNER (BY A. MERCHELL)**

Arthur Elrod created spectacular interiors for homes designed by architects such as Richard Neutra, William Cody, John Lautner, and E. Stewart Williams. Recognized as the ultimate professional, a perfectionist with both charm and elegance, Elrod was passionate about interior design. A native of Atlanta, he attended Clemson College in South Carolina and studied interior design at Chouinard Art School in Los Angeles. Elrod began his career as a designer at Bullock's, in Palm Springs, and then worked at W & J Sloane, in San Francisco. In 1953 he established his own design studio in Palm Springs, which became Arthur Elrod Associates ten years later. His residential clients included Lucille Ball, Bob and Dolores Hope, Jack Benny, Winthrop Rockefeller, and Moss Hart, as well as clients in Chicago, Houston, Oklahoma City, and many other cities. The Johnson Publishing Corporate offices in Chicago, the original El Dorado Country Club in Indian Wells, and Rooms of Tomorrow in New York City are a few of his numerous commercial design projects. His own home on Southridge in Palm Springs, designed by architect John Lautner, is perhaps his best-known project. He was killed in a car accident in 1974, at the age of 50.

● **ALBERT FREY (BY A. MERCHELL)**

Born 1903 in Switzerland, and educated there. Worked for Le Corbusier in Paris in 1928. Moved to New York in 1930 and became partners with A. Lawrence Kocher; in New York, where they built the Aluminaire House. Came to Palm Springs in 1934 to supervise construction

Architects Roger & Harry Williams (1946).

174

of the Kocher-Samson building. In 1939, Frey permanently relocated to Palm Springs, where he would design a body of work including residential, commercial, institutional, and civic buildings.

● DONALD WEXLER (BY A. MERCHELL)

Born and educated in Minneapolis, Wexler moved to Los Angeles after World War II to work for Richard Neutra. He later moved to Palm Springs to work for William Cody and eventually partnered with Richard Harrison, specializing in institutional projects. Through this work, Wexler developed an expertise in prefabricated-steel construction, best visualized in the Alexander Steel Houses. Other projects completed were the Spa Hotel Bath House, the Canyon Club Inn (now demolished), the Palm Springs airport, schools, gas stations, hospitals, the Convention Centre, the Dinah Store...

● STEWART WILLIAMS (BY A. MERCHELL)

Eldest son of Harry Williams, architect of the La Plaza Shopping Center in Palm Springs. East Coast educated. The first building he designed in Palm Springs was the Frank Sinatra House in 1946. He went on to design numerous hotels, retail stores, medical buildings, and residences, as well as three significant banks on S. Palm Canyon Drive. The most accessible and dramatic public building is his Palm Springs Desert Museum, where the ticket office (late 1990s) was his last built project.

From top to bottom: Stewart Williams; Donald Wexler; Albert Frey.

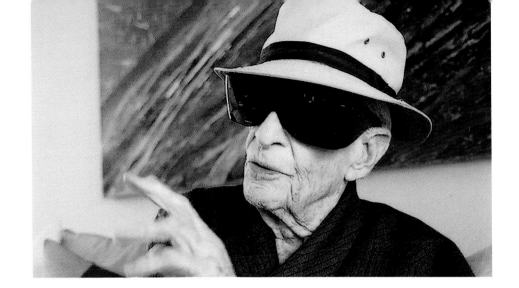

TESTIMONIES

● FREY II

Janice Lyle, executive director of the Palm Springs Desert Museum: "My husband and I are now living in Frey House II. We have taken on the role of caretakers of the house and are pleased to talk with architects and architectural students about it. Albert Frey's will stipulates that the house could be used as a residence, that the people who lived there should be knowledgeable about his work, and that it should be made available to architects and architectural students by appointment. The will also indicates that Frey did not expect the house to be open to the public. My husband and I both knew Albert personally: my husband had contact with him for twenty-five years, and I knew him for fifteen years. Both of us have a long personal and professional interest in architecture. We have reviewed the Frey archives, photographs, and drawings that are a part of the museum's collection. As a result, we are able to share both personal stories and factual information with the people who visit the house. Printed information about the house appears in Joseph Rosa's book on Albert Frey (probably the most reliable source) and in the picture book *Frey House I and II,* by Jennifer Golub. The museum is dedicated to maintaining the house in a condition as close to the original as possible. All decisions are being made based on archival information and the photographs taken of the house in the mid-1960s by Julius Shulman. Recently, the original carpets and slipcovers for the living room sofas were replicated."

Regarding how it feels to live in such an iconic house:

"It is an extraordinary feeling to be in the house looking out at the desert below. There is a serene quality to the space that is certainly the result of the proportions of the house and its integration into the landscape. We feel at one with nature and have to remind ourselves that we are only a minute from downtown Palm Springs. If we look toward the west and the north, we see only the mountainside, as if we were the only people in the world. If we look east and south, we see the green of the city, the red and brown rooftops of the houses, and the many blue swimming pools. The simplicity of the furnishings encourages us to live simply. Everything has a place, and we return those things to their place when we are finished with them. Living in this minimalist way lets your mind feel free. It is also a wonderful antidote to the daily demands of being a museum director. The serenity of the place is something that I hope to absorb and introduce into my frenetic work life."

● ELROD HOUSE

Michael Kilroy: "Sometime in 2002, I heard that the Lautner-designed Elrod House might be for sale. I was surprised to hear it. It was then owned by a multibillionaire who had spent considerable amounts of time and money restoring it, had owned it for eight or nine years, and was believed to view it, perhaps singularly among his various houses, as a sort of special retreat for himself and his closest friends. At the time, I already owned a higher-end, mid-century modern home elsewhere in Palm Springs, one I liked very much and had no intention of selling. The last thing I needed, I figured, was a second higher-end home in the same second-home town, not to mention the scramble involved to figure out a way to purchase it. Nonetheless, I had always wanted to see the house and figured that if I really liked it, then maybe the next time it came on the market, I might try to buy it.

As fate would have it, though, I really, really liked it. I expected it to be monumental and dramatic, which it was. I didn't expect it to also be warm, human in scale, or to feel so well-grounded. The experience of space there was such that I spent the next two months wondering how I could justify purchasing the home and, if I did, how I would actually go about doing it (though the house is significantly more valuable now, and the price I paid then can be considered almost a bargain, it was nonetheless quite expensive at the time, far more expensive than anything else that had sold in the area).

By December 2002, I started writing offers. By May 2003, the seller and I were in contract. The purchase closed escrow on either Friday, October 31, or Monday, November 3, 2003.

There are many things I like about the house. As radically different from most houses as it is, its difference is not as overt as one might think. It is subtle. The restraint inherent in the design is such that the myriad details comprising the house only gradually make themselves known. It is intensely tactile, yet those many interesting surfaces may not be noticed for weeks. It seems highly approximate in layout, finish, and look, yet over time one comes to notice just how finely-fitted every aspect is and to realize that almost every physical aspect of the home took incredible calculation, in an era of slide rules and protractors, to achieve. The views are large and dramatic at first glance, then often those same views are reframed and significantly re-defined, oftentimes more gently. Ultimately, a great sense of serenity is created. I am at the house two or three days a week. I've kept my other Palm Springs home, and I use both. In a sense, the other home is one of the better examples of design of the 1950s, and the Elrod House one of the best of the 1960s. I use it as a personal getaway, whether for the afternoon or a few days. Other times, I host events there or lend it to friends and associates. Recently, two friends and their first-born child, an infant then fifteen days old, stayed for four days. They were still a little shell-shocked from all the changes that come from having a child and hadn't

really yet ventured far from their own home. Their stay at the Elrod House became their first outing as a family. As bold and iconic as most photographs of the house show it to be, the photos my friends took during their stay showed just how warm and gently all-enveloping it can also be. That range of effect experienced here, from striking venue to warm and suffusely lighted nursery for a newborn and her parents, sums it all up for me."

● D'ANGELO HOUSE

Bill Butler: "The D'Angelo House is a 750-square-foot all-aluminum construction of lower weight and heat resistance. The house sits on two acres and adjoins another forever-wild two acres.

–Proposed reasons for building house:

To store Floyd D'Angelo's collection of African game trophies

As a weekend retreat from L.A.

To test the use of aluminum in home construction as a possible business expansion

–Mechanics of the house:

Rotates through a 130-degree arc

Originally driven by a photoelectric cell that timed the rotation to the movement of the sun in order to avoid direct light on the windows. The original movement was imperceptible. The house moved during the day and returned to the starting position at night. The rotation could also be controlled manually.

–Infrastructure:

All plumbing brings water and waste into and out of the house through rotating universal joints located in the central support column. Electrical connections run off flexible cable hookups from the central column. The fireplace is fed from a propane tank attached to the underside of the house so that it rotates with the house. The HVAC unit is also attached to the underside of the house and rotates with it. Although the HVAC unit is new, the original unit was attached in the same way.

–Restoration:

When purchased three years ago, the house had essentially been uninhabited for many years. The motor and external drives were missing. The HVAC had been replaced with an external unit that used ductwork crossing the tracks, on which the wheels revolve, rendering the house immobile. The outside of the house showed evidence of multiple layers of paint, including green, blue, pink, and beige. The inside of the house was filthy from years of neglect. Five windows were cracked. The carpeting was rotting, as were the drapes. In one area, holes had been drilled into the walls to hold up a cabinet. The good news was that since the house had

been neglected, it was, therefore, essentially unchanged from its original 1961 state. Thus, the appliances, for example, are all original, including a wonderful 1961 turquoise French under-the-counter refrigerator, which began humming and cooling away as soon as electric power was restored to the house; it did need to be defrosted however. The cooktop and exhaust hood are original. The small hot water tank under the kitchen sink is original. The light-switch plates are original and quite unique. One GFI outlet on the kitchen counter is new; however, it has been artificially aged to look the same as the original outlet covers.

The color in the interior is original. It required more than three months of tedious cleaning with toothbrushes and rags to get the accumulation of forty years of grime off the walls, ceiling, and ceiling struts. Holes in the walls and ceiling were repaired, and the original color was matched so that the repairs are essentially invisible.

The carpeting is new, as are the tiles in the kitchen, dressing room, and bath. The tiles are true, however, to the original. The original carpeting can be seen on the four stools surrounding the fireplace. The stones and accessories in the fireplace are original.

The curtains are new; however, they were designed based on the original drapes, which still hung in the windows when I bought the house. The fabric was matched, and the originals were used as templates for cutting and sewing these. The curtain mechanicals are original.

The broken windows were replaced. The offending neighbor who broke them by using the empty house as a golf driving target was politely but firmly told that no more golf balls were to be driven toward the house; implied threats were left to hang in the air. In the window by the bed, a section of the glass was cut and framed in aluminum—what else?—so that it could slide open for ventilation…not too effective, but a great idea.

By serendipity, I met Mr. Harry Conrey, of Temecula, California, about two years ago. Harry was a friend of Floyd's and, as an employee of the Garrett Corporation, an aerospace company in L.A., was familiar with the mechanics necessary to build the rotation mechanism. He had worked with Floyd on the construction of this house, helping to specify the motor and gearing assembly. So Harry was now able to locate for me through the still extant Garrett Corporation—though under a new name—the catalog that provided me with the same motor as the original, the same external gear assembly, and the wheels needed to replace the orig-inals—which after forty years of nonuse had flattened on one side. The mechanicals took considerable time to rebuild, but the house functioned perfectly from the first flip of the switch…despite a moment's hesitation, as if age had given the house reason to pause before attempting any movement.

The restoration work, including the amazing color matching, was done almost entirely by Juan Carlos Velasquez and Celedonio Torres. The electrical work and rebuilding of the

motor and gear assembly was done by my good friend Thomas Rendo, an architectural engineer, free spirit, and indispensable individual. Funding for this project was not provided by a grant. I wish it were.

I, in fact, showed the house this morning to a group of historic preservationists from all over California and Nevada. It was and always is amazing and thrilling to see the expression on people's faces when the house first revolves. It is also wonderful to see how much it infects them with laughter and just plain good vibes, the way it affects me every time I spend a day there. From the most beautiful view in America to the incredibly complex desert landscape on which it so gently rests, the house is a constant reminder that the perfect building enters your being, ambushes your psyche, and changes the way you see the world and yourself."

● LOEWY RESIDENCE

Jim Gaudineer: "Loewy House—indeed a collaboration between Loewy and Albert Frey. They were very different: Frey—Le Corbusier, organic, desert. Loewy—'show the time.' Loewy's place in design history is that of the right man at the right time. He is often called the father of modern industrial design. Both Frey and Loewy liked the American desert: its ruggedness, its light, its serenity. We find it a privilege to live here and have for twenty years tried to be good stewards in restoring the original house while making it work for us in 2004. We built the new hall gallery to connect the original 1946 house to the 1960 addition—the work of architects Marmol and Radziner, based in Santa Monica, California. They worked extensively on Neutra's Kaufmann House, which is next door to ours. Both houses were built at the same time, by the same contractor. Imagine Frey, Neutra, and Loewy on hot afternoons in 1946 surveying the week's accomplishments."

● KAUFMANN HOUSE

Elizabeth and Brent Harris: "The Kaufmann House is supremely tranquil and ever changing for us. And it has been so since it was finished in December 1997, following a thorough, pure, and historical five-year restoration (the new pool house, added on an adjacent lot in October 1998, completed the project, along with the desert landscape restoration). It is warm in feel, despite the common thought that a modern house is 'sterile.' Other Neutra home owners have said the same thing over the years, we hear. We love its privacy, but also its dramatic view of the mountain escarpment and Mount San Jacinto at over 11,000 feet. On its two and one-quarter acres, we have plenty of natural desert landscaping, allowing our two children room

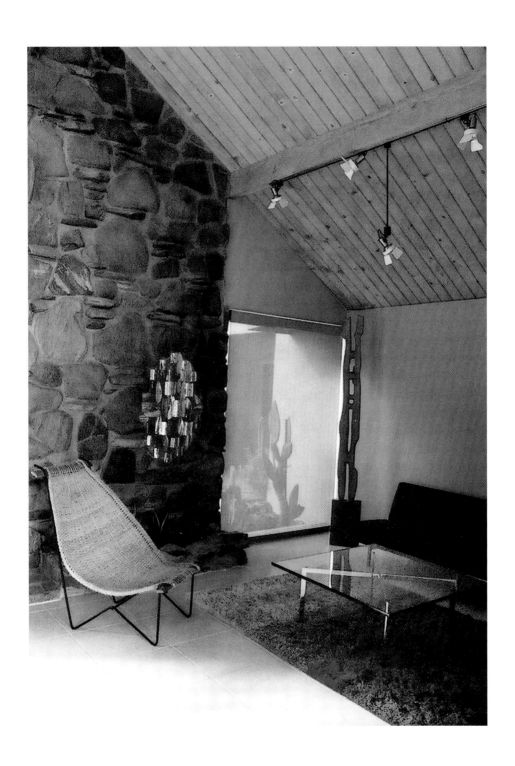

to roam and explore nature. Close to the house is the large rectangular pool and the grass 'carpet' that creates the finished refinement to this outside/inside house. The transitions created by the large window walls (of steel mullions, made before aluminum was commonly used) allow for the house to truly be open to nature. The floors are radiant-heated inside and out—and allow the family and our guests to transition on spring and fall days without a dramatic notice of a temperature change. In that way, it was perhaps Richard Neutra's best site expression of Southern California inside/outside living, and with the green privacy he found so important for a healthful and peaceful life. The house is as contemporary today as the day it was built—it has not suffered a style age, and in the restoration only central air and some earthquake upgrades were added (which serve to maintain and preserve its longevity). We feel the house and its estate is the best way to savor Palm Springs, and being inside its grounds we don't find much need to leave it. This was common in the way that Palm Springs houses and their use evolved since the 1940s particularly in the old Las Palmas neighborhood in which it is located. The Kaufmann House is a full expression of that.

When the sun goes behind the mountains, creating what famous photographer Julius Shulman, now 93, called Alpenglow, we often invite friends and family upstairs to the 'gloriette' for a toast and a warm fire. The gloriette has aluminum louvers that can be moved and that block wind (or open to the desert) with a partial view down the valley—and is a spectacular place for this innovative outside living room. The house, and the gloriette in particular, has been featured in many photo shoots, and was the background several years ago to a cover shot for *Vanity Fair* magazine (with Julianne Moore). (Note: we credit the garden design and plant specs to Eric Lamers on the Kaufmann House, west lot, north lot, and street lines. We credit William Kopelk with 'lot 9,' which is the secret garden to the east of the tennis courts. All are fantastic spaces in our view.)"

● GRACE LEWIS MILLER HOUSE

Catherine Meyler: "It is morning in February in Palm Springs. The sun rises early, and the first rays shine in through the glass walls that wrap around the southeast corner of the house. As the first rays begin to warm the house, they also hit the reflecting pool and send shimmering patterns on to the ceiling. These patterns are mirrored by the patterns of the wood grain, which make up the wainscoting of the walls and built furniture.

The house was designed to be inhabited mostly during the winter months, when the sun is low and shines in below the wide overhangs. In the summer months, when the sun is high, the overhangs prevent the sun from shining in directly and so help the house stay cool. During the morning hours, the sun keeps the house warm and negates the need for alternate

heating. The textured glass of the northern exposure—originally designed as an exercise studio—keep the room filled with soft, luminous light. It creates a very calm and serene atmosphere. In the kitchen, I juice grapefruit while looking out into the garden through open windows, and marvel again at the 'hole-in-the-corner,' a lidded aluminum trash chute that leads directly from the tiled surface next to the sink to a trash can accessible only from the outside. With perfect aim, I lob the juiced rinds through the hole and close the lid. No drips, no smells, and no garbage to haul through the house. I set up my breakfast tray on the patio outside the back door and sit there, gazing at the wondrous mountains, with snow on the peaks and green from the recent rains below. Off to the shower, which also affords a view of the mountains. Through the middle of the day, the house stays comfortably warm, and the gardening chores are a pleasure. As the sun moves speedily west, I open the west-facing French doors of my bedroom. Neutra created the two doors to open and lock down against a screen, the frame of which sits perpendicular to the two door frames. The result is a small, screened-in porch, which allows the sun to warm the bedroom and the sound of trickling water from the fountain immediately outside the screen to calm and soothe. Originally, Neutra designed a citrus orchard in the northwest corner of the property, and the smell of the blossoms would waft into the house. I plan to re-create this orchard in the future.

As the sun drops behind the mountain at about 3:30p.m., it is time to light the fire in the living room. It is a large hearth, and the warmth soon spreads throughout the room, again negating the need for artificial heat. As friends arrive for dinner, they sit on the comfortable built-in furniture around the fireplace and chat. The warmth of the oven heats the kitchen, and dinner is served in the old screened-in porch. This is now glassed in, as the room would only be available as a dining room for a limited time during the year, so for practicality I will keep the glass. The warmth of the fire drifts through from the other room, and it is very comfortable. After dinner, we sit again by the fire, and take a stroll outside and admire the reflections of the house in the reflecting pool, and comment again on how warm and inviting the house looks from the outside. As my guests leave, I quickly clean up in the still-warm kitchen and retire to the bedroom. It is chilly as I dive beneath my huge duvet and reflect upon the perfect day. I couldn't wish for a more ideal home. Neutra's design focused on the architecture of the house creating an environment that soothes the soul and enriches one's life. Every detail is deliberate, every perspective and proportion is perfect.I absolutely love my house!"

● THE SHIP OF THE DESERT

Trina Turk: "When we drive up to the house after the two hours' commute from L.A., we are always happy to be in Palm Springs and to see the house with the mountain behind it. Possibly because of the curved shapes of the streamlined modern architecture, the house has a very warm, enveloping feeling. Since Jonathan and I are both in visual fields of work, we like the simplicity and spareness of the architecture and the desert; it gives our eyes a chance to rest. If we want something to look at, we just have to look out the windows or go outside to the view of palm treetops or of the mountain. There is also a lot of wildlife living around the house: rabbits, snakes, lizards, roadrunners, quail, bats, desert mice—which are an endangered species—hawks, and in the summer, chuckawallas, which are large lizards that sit on the rocks in the sun. They are one and one-half to two feet long, including their tails.

Our favorite thing is to sit by the pool at night with friends, just talking, smoking, drinking. The desert air, with the turquoise glow of the pool and the lights of the town below, make a very relaxing atmosphere. We also love to have guests stay for the weekend, the house can hold eight to ten people comfortably, each with their own bathroom, so it's like a little hotel. Everyone always says they sleep very well at the ship house."

● BOUGAIN VILLA

Dorothy Meyerman: "Climbing the hill, one arrives at the gate to view a scene of unimaginable beauty—a dwelling, growing almost organically out of a ledge carved into the mountain, with the whole of Palm Springs spread out below. I love the view at night: diamonds on velvet. I love the view in the morning at sunrise, the pink glow slowly rising over the mountain and filling the glass-walled house with magical light. On hot days, the splash of waterfalls, the shimmering koi swimming lazily through connecting fishponds, the tumbling falls of dazzlingly colorful bougainvillea. These are a few of the reasons why I love this house and why we bought it." And Harold Meyerman adds: "Since my wife and I are both from Europe, we can probably attribute some of our comfort to living in an environment full of furniture and furnishings originally designed by several now famous Europeans. The Palm Springs year-round climate is also magical, as is the location of our property, high above Palm Springs and nestled in the mountains in such a way as to minimize disruption of the natural beauty. We also love making the house available to the public for showings since we believe that the property belongs as much to them as to us. Our goal is to leave the property in better shape than we found it so as to make it a joy to behold for future generations."

The Four Hundred indoors, a condominium on Arenas Road
designed by Palm Springs mid-century architect Herbert W. Burns.

● SANDPIPER CONDOMINIUM

William Krisel, architect; description of Sandpiper:

–One of the first condominium projects in the Palm Springs desert area

–Conceived as a second home in the winter season

–Swimming pool was point of focal-visual image

–Private, quiet, views were the guiding design criteria

–Captures the beauty of the mountains

–Walk/lanscape patterns reflect desert angles

–Lanscape pallete of desert plant materials

–Low lighting at night, illuminating garden and walks

–Encompasses the artistic, experimental, social, environmental, technical, and professional results that are enduring without destroying the neighborhood."

Krisel's philosophy on architecture:

1. The architect is the captain of the "built environment" team.

2. The architect is the master builder and master designer.

3. The architect must create projects that are: (a)comfortable, (b)cost-effective, (c)memorable.

4. The architect must be tenacious, vigorous, and a leader in design.

5. The architect must bring together all professionals involved in the building environment.

6. As the captain, the architect must control the end-product.

7. The architect must produce projects of consequence by combining: (a)thought, (b)discipline, (c)integrity—along with theory, history, philosophy, science and technique, craft and process— all overlaid into a truly multidisciplinary, balanced result.

8. The architect must believe that no detail is too small to consider.

9. The architect must create a balanced design of vision, budget, and program, along with sometimes painful compromises with clients.

10. The architect must integrate the project with society, community, and history to promote healthy growth.

11. The architect must earn the right to have a balanced practice to demonstrate not only how to live but also how to build; this involves risk taking and professional growth.

12. The architect must have respect for the modernist masters.

Architecture is an agent of change, to make a positive impact on society.

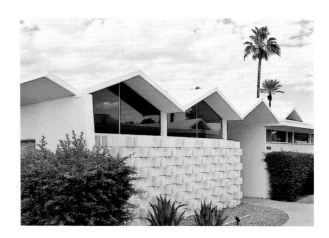

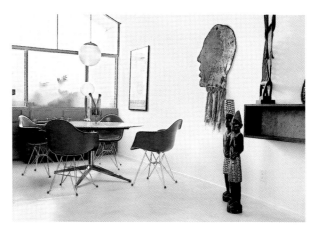

From top to bottom: the Park Imperial South Condominium and the Seven Lakes golf.

Steel House designed by Donald Wexler.

● BIBLIOGRAPHY

Billard, Thomas and Buisson, Ethel *The Presence of the Case Study Houses,* Birkhauser, 2005.

Collectif / IIIème Rencontre de la Fondation Le Corbusier, *Le Corbusier et la nature,* La Villette, 2004.

Cygelman, Adèle *Palm Springs Modern, Houses in the California Desert,* preface by Joseph Rosa, photographs by David Glomb, Rizzoli, 1999.

Danish, Andrew and Hess, Alan *Palm Springs Weekend, The Architecture and Design of a Mid-Century Oasis,* Chronicle Books, 2001.

Golub, Jennifer *Albert Frey, Houses 1 and 2,* Princeton Architectural Press, 1999.

Hess, Alan and Weintraub, Alan *John Lautner,* Thames and Hudson, 2003.

Jackson, Lesley *Contemporary Architecture and Interiors of the 1950s,* Phaidon, 2004.

Lamprecht, Barbara *Neutra,* Taschen, 2004.

Leet, Stephen *Richard Neutra's Miller House,* Princeton Architectural Press, 2004.

Neutra, Richard *L'architecture d'aujourd'hui,* monthly, no. 6, May—June 1946.

Shulman, Julius *Architecture and its Photography,* Taschen, 1998.

Rosa, Joseph *Albert Frey, Architect,* Princeton Architectural Press, 1999.

Serraino, Pierluigi *Modernism Rediscovered,* with photographs by Julius Shulman, Taschen, 2000.

Trétiack, Philippe *Raymond Loewy,* Assouline, 1998.

Védrenne, Élisabeth *Le Corbusier,* Assouline, 2001.

Williams, Stewart *Palm Springs Desert Museum,* the Palm Springs Desert Museum, 1979.

The author would particularly like to thank Robert Imber for his invaluable connections, for his patience, and for sharing his knowledgeable passion for Palm Springs; Bill and Katherine Butler for their sweet hospitality and their recommendations; Tony Merchell for sharing his specialized knowledge; all of the aficionados, owners, designers, architects, antique dealers, and hotel managers who provided their insight and friendly help: Stewart Williams, Donald Wexler, Julius Shulman, Catherine Meyler, Harold and Dorothy Meyerman, Andrew Mandolene and Todd Goddard, William Kopelk, Brent Harris, Michael J. Kilroy, Jim Gaudineer, Trina Turk and Jonathan Skow, Sidney J. Williams, Dr. Janice Lyle and Michael Boyer, John Finkler, Kurt Bjorkman, Courtney Newman, Joe Kelley, Jacques Pierre Caussin, Patrick Barry, Steven Lowe, David Lee, James Coyne, Jim Isermann, Neeraja Lockart, Jim and Karen West, Julio Zavaleta, Lyn Wathall, Lena Zimmerschied, Mary E. B. Perry, Gregg Rapp, Tim Clarke, Jean Loubat, Bonnie Mosher, the Lazar family, Emmanuel Rubin, Magnus Naddermeir, Oreste M., Eric Tirelli, and Cyril Lesaffre; Papito and Mamita; and a very special thanks to my publishers, Martine and Prosper Assouline, and their talented team, for looking, listening, and sharing.